Lust, Lies and Monarchy

The Secrets Behind Britain's Royal Portraits

STEPHEN MILLAR

Museyon

New York

Names: Millar, Stephen, author.
Title: Lust, lies and monarchy : the secrets behind Britain's royal portraits / Stephen Millar.
Description: New York : Museyon, [2020] | Includes index.
Identifiers: ISBN: 9781940842288 | LCCN: 2019953309
Subjects: LCSH: Great Britain--Kings and rulers--Portraits. | Great Britain--Kings and
rulers-- Biography. | Queens--Great Britain--Portraits. | Queens--Great Britain--Biography.
| England--Kings and rulers--Portraits. | England--Kings and rulers--Biography. | London
(England)--Guidebooks. | BISAC: HISTORY / Europe / Great Britain / General. | ART /
Subjects & Themes / Portraits.
Classification: LCC: DA28.1 .M55 2020 | DDC: 941.0099--dc23

Published in the United States and Canada by:
Museyon Inc.
333 East 45th Street
New York, NY 10017

Museyon is a registered trademark.
Visit us online at www.museyon.com
ISBN 978-1-940842-28-8

Printed in China

To my children—Patrick, Anna, Blythe and Arran

Lust, Lies
and Monarchy
The Secrets Behind Britain's Royal Portraits

INTRODUCTION

T he British royal family can trace its origins back over 1,200 years, making it one of the most enduring ruling dynasties in the world. The fact that it has survived into the 21st century is testament to the family's ability to adapt to the religious, social, political and scientific revolutions that have impacted civilisation. Other European houses were swept away by these forces, but the British royal family has managed to change course, often just in time, to avoid being consigned to the history books.

The role of art in the monarchy's story is a small yet important one. In the modern age, it is hard to fathom that for many centuries most ordinary people would never see their sovereign in the flesh or have any idea of what he or she looked like. This lack of visual connection meant the monarchy was viewed as a distant institution, inevitable rather than celebrated.

The Renaissance and the invention of the printing press changed everything. Books and pamphlets were printed on a new scale, resulting in the spread of ideas that challenged the status quo. A concurrent revolution in the cultural sphere saw the emergence of great artists who began to achieve fame beyond their own localities.

It was at this moment of huge change in Europe that the Tudor dynasty claimed power in England, beginning with Henry VII. At this time England, Scotland, Ireland and Wales were seen by most people in mainland Europe as cultural and political backwaters, almost barbaric compared to the great kingdoms of Spain, Italy and France. However, the Tudors, conscious that many regarded them as usurpers, were determined to establish their "brand."

Art helped them do this.

Henry VIII, the archetypal Renaissance prince, had a deeply troubled reign. Having split with Rome over his marriage to Catherine of Aragon, he had enemies on all sides. To project the image of a strong, capable ruler, he employed the services of Hans Holbein the Younger, possibly the finest artist then working in Europe. The investment paid dividends.

Holbein's depiction of Henry in the Whitehall mural was said to overwhelm viewers, and it was copied and distributed widely. It remains to this day the defining portrait of Henry, the image most people think of when they think of the king. It also exemplified the nature of royal propaganda. To Henry's enemies, it projected the image of a strong king not to be messed with, to his subjects a ruler who would look after them. But it was not the real Henry, who was cursed by failing health, declining mental powers and open sores on his legs that refused to heal. Royal propaganda was about creating an impression, not reality. It was about lies, not truth.

Art was also important for diplomatic purposes. Holbein famously travelled Europe painting portraits of eligible young women for his master Henry to marry.

Elizabeth I continued her father's investment in art as a political tool. Hundreds of portraits of her were made during her reign, and most were subject to rigid rules about how she should be shown. This explains why she looks to be no older than in her thirties when she was painted near the end of her long life. Portraits of Elizabeth, particularly as it became clear she would not produce an heir, were designed to show her as a deity—the Virgin Queen—who could survive any obstacle, even multiple assassination attempts.

It was only in the 17th century that the royal family began to invest in art for art's sake. Prince Henry Stuart and his younger brother Charles I were the first serious art collectors in the royal family. Charles invested huge sums in buying art by the great masters, driving up prices. Whilst Charles genuinely appreciated art, his acquisitions also were a statement to other dynasties in Europe that the British royals were their cultural equals and were willing to spend what it took to catch up.

Charles I not only bought great paintings by dead painters, he invested in contemporary talents. His patronage of the Flemish painter Anthony Van Dyck made the standard of British royal portraiture the equal of anywhere else. Charles also commissioned busts by Bernini, and he enlisted Rubens to paint the ceiling of Banqueting House.

But Charles I had a major flaw: He was unable to read the way society was changing around him and consequently to adapt in order to survive. Convinced his power was God-given, he took on Parliament and the growing democratic institutions and lost—both the Civil War of the 1640s and then his head on a chopping block

in Whitehall in 1649. His enormous art collection was sold off, and for a few years it seemed the royal family was extinct.

However, whilst many disliked the royals, many also were scared of the chaos and anarchy produced by the power vacuum that followed the death of the Parliamentary champion Oliver Cromwell. Charles II was therefore invited back to take his father's throne in 1660. He was a canny ruler who concentrated on enjoying life rather than taking on Parliament. This endeared him to an exhausted country. But the king was also careful to commission works of art that re-established the grandeur of the monarchy. He also vigorously pursued the return of his father's art collection that had been sold off.

The public became fascinated with the goings-on at court. Charles had thirteen mistresses and multiple illegitimate children. The Dutch artist Peter Lely witnessed the scandalous life of the Restoration court at first hand, and the king sat for him many times. Lely also captured the licentious mood of the court when he was commissioned to paint the most beautiful women of its inner circle, many of whom had been mistresses of Charles and his brother. The series, known today as the Windsor Beauties, originally hung in the rooms of Charles' brother James, later James II. This was not art as royal propaganda, but a celebration of the fun-loving age, capturing the "pinups" of the late-17th century.

It was during the 17th century that the royal family began to lose control over how it was portrayed to the general public, largely due to advances in printing that made it easier to produce and circulate drawings and cartoons of the royals. The Civil War had made it

clear that the monarchy now played second fiddle to Parliament, and whilst the decline in royal power would take place over many decades, it also meant critics were more audible.

Artists and cartoonists regularly caricatured the Hanoverian regime that dominated the 18th century. George IV was perhaps the biggest victim of this new development. Much of the public disliked him on account of the stories circulating about his oafish ways—a glutton addicted to gambling, women and drink. The greatest artists of the day painted George, managing to hide his girth and ageing features, but they could not roll back the impression given by the unflattering caricatures of the monarch that were circulating in coffeehouses and elsewhere.

The 19th century saw a change in public morality, at least on a superficial level. Queen Victoria, who lent her name to the era and had no lovers (at least not until after her husband, Prince Albert, died), used art to project an image of morality and family, her dutiful husband and large number of children being painted numerous times.

As the political power of the monarchy faded, despite Victoria's attempts otherwise, the way the royal family was portrayed also changed. Royals could no longer count on an army to protect them, but were reliant on public opinion. When Victoria went into an extended period of mourning after Albert died, her absence from public life caused a wave of republican sentiment that taught the royal family a harsh lesson: Lose public support, and you could easily become extinct.

As a result, there was an increase in so-called "conversation pieces"—domestic pictures that showed the royals in a less formal, more sympathetic light and were designed to make a connection with ordinary people. Ironically, given the Victorian Age was meant to be synonymous with high standards of moral probity, Victoria herself courted controversy because of her close relationship with her Highland servant John Brown. They featured together in a number of paintings.

The template for the modern royal family we know today developed in the early 20th century. Family members, at least outwardly, led non-political, charitable lives, heavily involved in good deeds. The revolution brought about by photography, and then the moving film, meant the public in Britain and around the world had a much better idea of what members of the royal family looked like and how they comported themselves.

As a result, the role of traditional art became less important. When new kings or queens were crowned, the obligatory coronation painting was commissioned, but it no longer held the same relevance. Great artists were still drawn to painting the royal family, but their livelihoods no longer depended on having royal patronage.

The small painting of Elizabeth II by Lucian Freud is an example of just how much things have changed. It is a fine and interesting painting, but it neither flatters nor does it define the image of the monarch for most people in this age of saturated media and social media coverage. However, ask people to think of an image of Henry VIII, and most will think of Holbein's grand, authoritative portrait (whether they are aware of the artist's identity or not).

PLACES REFERENCED OUTSIDE LONDON

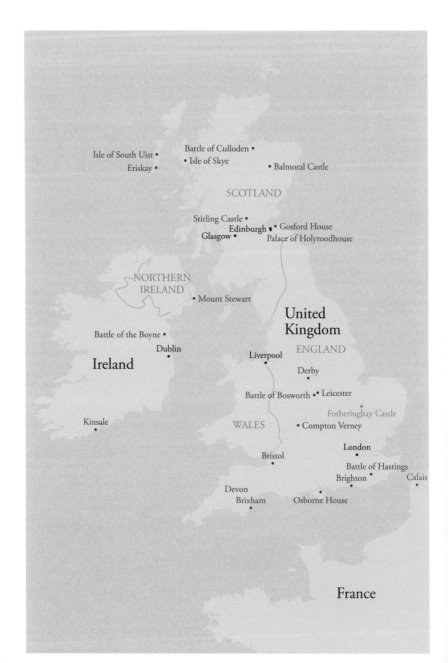

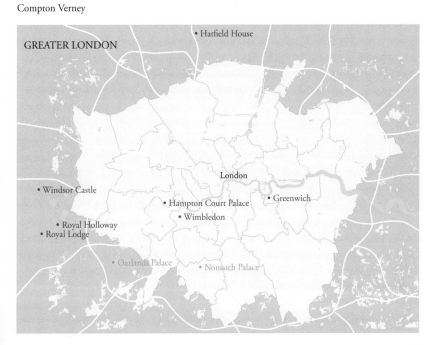

GREATER LONDON

• Hatfield House

London

• Windsor Castle

• Hampton Court Palace • Greenwich

• Wimbledon

• Royal Holloway
• Royal Lodge

Oatlands Palace • Nonsuch Palace

THE PRINCES IN THE TOWER: MURDER MOST FOUL

Where are the bodies?

The Murder of the Sons of Edward IV
1835, Theodor Hildebrandt, oil on canvas, 59.1 x 69 in
(150 x 175.2 cm), Museum Kunstpalast, Düsseldorf

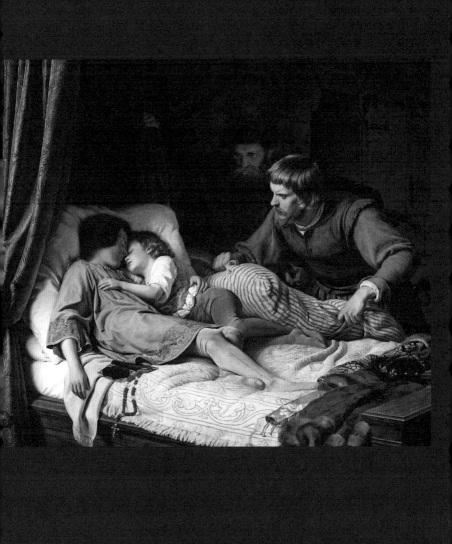

In the summer of 1483, two brothers, the elder aged twelve, the younger just nine, played games with each other as best they could within the few open spaces of England's most feared prison—the Tower of London.

Separated from their mother, and still mourning the death of their father just a few months before, the two boys must have been worried. However, their uncle, the man whom their father chose to ensure their safety, assured them their stay was just temporary. He promised them that a coronation ceremony was being organised at which the elder boy, already king of England upon his father's death, would be crowned.

But as the days went by, it must have gradually become clear to them something was wrong. There was no coronation. They were prisoners.

The boys, Edward and Richard, were the sons of Edward IV and princes of the realm. When their father died, the elder boy automatically became Edward V.

Because of their age, their uncle Richard, Duke of Gloucester, was appointed Lord Protector.

However, the duke had no intention of letting his nephew sit on the throne. Instead, he constructed an elaborate argument that his brother, the deceased king, already had a wife before he married Elizabeth Woodville, mother of the two princes. As a result, according to the duke, the two boys were not princes at all but illegitimate and the duke was instead the true claimant to the throne.

It is thought the duke, now declared as King Richard III, turned to his loyal aide Sir James Tyrell to organise the murder of the princes. Between 1513 and 1518, Thomas More wrote his *History of King Richard III*, and in it he described what happened next:

"Tyrell appointed Miles Forest, one of the four that kept them, a fellow hardened in murder before that time. To him he joined one John Dighton, his own housekeeper, a big, broad, square strong knave. Then all the others being removed from them, this Miles Forest and John Dighton about midnight (the innocent children lying in their beds) came into the chamber, and suddenly lapped them up among the bedclothes—so bewrapped them and entangled them, keeping down by force the featherbed and pillows hard unto their mouths, that within a while, smothered and stifled, their breath failing, they gave up to God their innocent souls into the joys of heaven, leaving to the tormentors their bodies dead in the bed. … They laid their bodies naked out upon the bed, and fetched Sir James to see them. Who, upon the sight of them, caused those murderers to bury them at the stair-foot, suitably deep in the ground, under a great heap of stones."

Around eighty years after More wrote his history, William Shakespeare, who would have been familiar with More's account, drew upon it when writing his play, *Richard III*, in which the character Tyrrel recounts the murder of the princes in Act IV:

The tyrannous and bloody deed is done,
The most arch of piteous massacre
That ever yet this land was guilty of.
Dighton and Forrest, whom I did suborn
To do this ruthless piece of butchery,
Although they were fleshed villains, bloody dogs,
Melting with tenderness and kind compassion
Wept like two children in their deaths' sad stories.
'Lo, thus,' quoth Dighton, 'lay those tender babes:'
'Thus, thus,' quoth Forrest, 'girdling one another
Within their innocent alabaster arms:
Their lips were four red roses on a stalk,
Which in their summer beauty kissed each other.'

Shakespeare's depiction of the hunchbacked, evil Richard III has continued to shape most people's view of the monarch, with the murder of the princes regarded as his most heinous crime.

However, the facts are more complex. Shakespeare wrote his play when Elizabeth Tudor was on the throne, and it was Henry Tudor whose army had killed Richard III at the Battle of Bosworth in 1485. The playwright would not have wanted to offend his royal patrons by portraying Richard in anything other than a poor light.

The chaotic, violent world of England in the late-15th century contained rivalries and feuds that

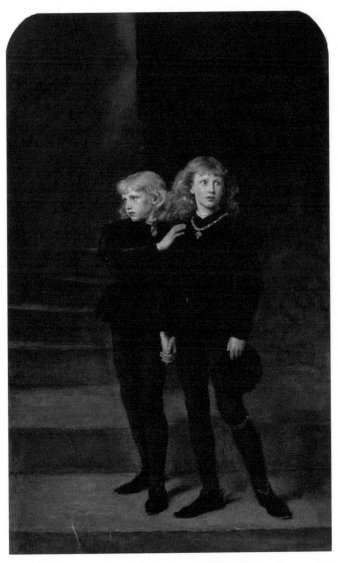

The Princes Edward and Richard in the Tower (1483), 1878, John Everett Millais,
Royal Holloway, University of London

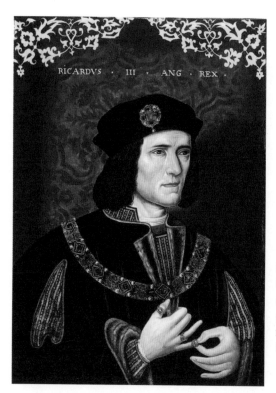

King Richard III,
late 16th century,
unknown artist, oil on
panel, 25.1 x 18.5 in (63.8
x 47.0 cm), National
Portrait Gallery, London

make plotlines in *Game of Thrones* look subdued, and
many have suggested that other suspects were behind
the murders instead of Richard. It is not even certain
that More's account of what took place in the Tower
is correct, as he drew on sources that are now lost.
However, More was an intelligent, thorough man, with
access to State papers and was writing only a few decades
after the boys were imprisoned in the Tower. It seems a
fair bet that he was correct.

Richard did not live long enough to enjoy being
king, and he took his secrets with him when he died

at Bosworth. In the years that followed, men would appear claiming to be one of the princes. In 1490, Perkin Warbeck sought the throne as Richard, the younger brother, and led a number of armed uprisings against Henry VII. When finally captured by Henry, he confessed to being an imposter and was imprisoned in the Tower of London before being hanged.

Four hundred years after the tragic event, the death of these innocent children caught up in a brutal struggle for power continued to provoke a strong emotional response among artists and the viewing public throughout the world. Notable 19th-century academic artists who depicted the tragic princes were Frenchman Paul Delaroche, Brazilian Pedro Américo, Englishman John Everett Millais and German Theodor Hildebrandt, whose painting from 1835 most closely illustrates Shakespeare's imagery, down to the princes' alabaster arms and red roselike lips.

Part of the continued fascination with the tragedy was the mystery of what really happened to the children, hinted at by Thomas More. The first real evidence surfaced in 1674 when workmen discovered the skeletons of two children buried near a chapel in the Tower of London. King Charles II, then monarch, had the remains interned in Westminster Abbey, and commissioned Sir Christopher Wren to design a marble sarcophagus, whose inscription, translated from the Latin, reads in part:

Here lie the relics of Edward V, King of England, and Richard, Duke of York. These brothers being confined in the Tower of London, and there stifled with pillows, were

privately and meanly buried, by the order of their perfidious uncle Richard the Usurper ...

Forensic tests on the remains interned in Westminster Abbey could finally put beyond doubt whether they are those of the princes, but the present monarch Elizabeth II and the Church of England have to date refused to allow any examination to take place.

In a final twist, the body of Richard III was discovered in 2012 under a car park in Leicester, where he had rested since being killed at Bosworth in 1485. His remains were reburied in Leicester Cathedral with full honours in 2015. Actor Benedict Cumberbatch, who played the king in a BBC production of Shakespeare's play the following year, read a poem at the ceremony that had been specially written for the event by the poet laureate, Carol Ann Duffy. Cumberbatch's involvement was particularly appropriate as the actor is a second cousin, 16 times removed, of Richard III.

HENRY VII: THE EXPLORER KING

Establishing England's claim to North America with John Cabot

John Cabot and His Sons Receive the Charter from
Henry VII to Sail in Search of New Lands, 1496
1910, William Denis Eden, the East Corridor of the Houses of Parliament,
London, Parliamentary Art Collection

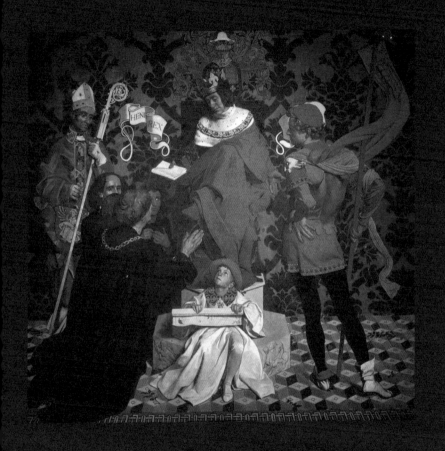

By the late-15th century, Europe was in turmoil. Wars, famine, disease were rampant. This was the time of dark, disturbing figures such as Machiavelli, but also an age that produced Michelangelo and da Vinci. Against this background, world exploration and the building of new empires were on the minds of powerful men. One of the most important events in the development of Western civilization took place in 1492 when Christopher Columbus, an Italian sailing for the Spanish monarchy, spied what became known as the New World. The unknown was becoming the known, and no one wanted to be left behind in the race for new glories, no matter how dangerous or costly the price. Which European monarchy would achieve world domination?

In May 1497, a small, 70-foot-long ship named the *Matthew* left the English port of Bristol under the command of Venetian explorer Giovanni Caboto. Better known by the anglicised version of his name—John Cabot—he led a crew of no more than twenty men across the Atlantic Ocean to where no European had been since the Vikings.

Like Columbus, Cabot was desperate to find a new sea route to Asia, and the fabled lands of Cathay (China) and Japan. The historic trade route along the Silk Road to Asia was controlled by Venice and had been disrupted during Cabot's lifetime by wars. Other explorers sought to reach Asia by sailing around Africa, but Cabot believed sailing west across the Atlantic was the best route.

King Henry VII, the first Tudor king of England, agreed. Ferdinand and Isabella, Spain's rulers, had bankrolled Columbus' voyages, and news of his discoveries made other European rulers sit up and take notice. Henry had already turned down Columbus a few years before and must have regretted passing on the opportunity as stories spread of treasure ships carrying gold back to Spain from new lands. Henry also knew the pope was recognising the new lands discovered by Spain and Portugal. England had to make its discoveries—and fast—or risk being accused of stepping on its rivals' toes.

How Cabot, a foreigner with an uncertain past and no great reputation as a seafarer, came into the confidence of King Henry is one of the most unlikely stories in the history of world exploration.

Just a few years before, Cabot was living in Venice (he may have been born, like Columbus, in Genoa). Something went wrong with his business ventures, and he ended up a debtor hounded from Venice by his creditors, likely never to return. Charismatic, a quick learner and possibly a chancer, he fled with his family into Europe, his creditors in hot pursuit. In Valencia, he tried, and failed, to convince the authorities to let him reconstruct their harbor. He moved on to Seville, where

he obtained a commission to build a bridge, but the project fell through.

This was happening at a time when Columbus was bringing back exciting news of his history-changing discoveries for the king and queen of Spain. It has been suggested that Cabot even served on one of Columbus' voyages, which may explain why an insolvent, failed builder in Seville with no reputation for undertaking voyages managed to convince seamen, financiers and, most importantly, the king of England to back his plan to head across the Atlantic.

He arrived in England in 1495, quickly making connections with the merchants and sailors of Bristol—an important port on the southwest coast—as well as Italian financiers and merchants in London. It was in London that Cabot's luck continued, and he secured an audience with King Henry VII.

Evidently Cabot sold the idea of a voyage of exploration to find a trade route to the fabled Cathay to the king because Henry granted Cabot and his sons formal permission to go. Denis William Eden's oil painting from 1910, displayed in the East Corridor of the Houses of Parliament, captures the moment in March 1496 when Henry VII issued the letters patent, thereby authorising the journey.

In the painting, Cabot and his three sons kneel before the king who sits high upon his throne, his left leg crossed casually yet magisterially over his right. The king extends his right hand down to the explorers, giving them his written royal authority to explore. To represent the charter's purpose, the artist inserts a young, well-dressed page sitting at the foot of the monarch. The

youngster holds a furled map of the then-known world. Figures representing the Church and State flank the tableau.

History records the terms of the patent:

Be it known and made manifest that we have given and granted as by these presents we give and grant, for us and our heirs, to our well beloved John Cabot, citizen of Venice,

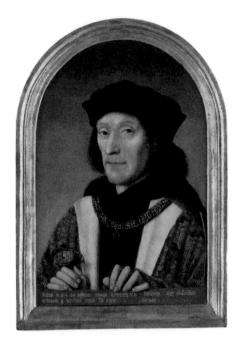

King Henry VII, 1505, unknown artist, oil on panel, 16.8 x 12 in (42.5 x 30.5 cm), National Portrait Gallery, London

and to Lewis, Sebastian and Sancio, sons of the said John … full and free authority, faculty and power to sail to all parts, regions and coasts of the eastern, western and northern sea, under our banners, flags and ensigns … to find, discover and investigate whatsoever islands, countries, regions or provinces of heathens and infidels, in whatsoever part of the world placed, which before this time were unknown to all Christians.

Having arrived—and survived—in a foreign country, Cabot had already achieved a great deal over a short period of time, but now he had to actually carry

Discovery of North America by John and Sebastian Cabot,
A. S. Warren, 1855

out what he had promised Henry. It seems his first
voyage out of Bristol after receiving the royal order failed
for some unknown reason. But in May 1497 Cabot set
off in the *Matthew* from the same port on the voyage
that would define him.

 After just a few weeks at sea, on June 24 Cabot
and his men spotted land. No one knows exactly where

the *Matthew* landed but it is commonly thought to have been in what is now Newfoundland in Canada. When Cabot set foot on shore, he planted the English flag and also that of the pope. The explorers found evidence of habitation and saw some natives running away at their approach, but they hesitated to venture farther inland. One contemporary reported they went no farther than an arrow shot from a crossbow.

Having established England's first claim to land on the North American continent, just as the Spanish and Portuguese had begun to carve out their own territories farther to the south, Cabot turned the *Matthew* around. The explorers arrived back in Bristol in August 1497 to a triumphant welcome. Cabot rushed to London to report on his success to Henry VII and received a reward of £10 and a pension. Cabot's exploits were discussed throughout Europe, and letters were sent from England back to Columbus reporting on the progress of his new rival.

Contemporaries during this time said that Cabot, puffed up by the king's attention, alluded to himself as a prince or a great admiral, and for a while he must have believed his fortunes had changed dramatically for the better.

A few months later, in February 1498, the king granted Cabot new letters patent to undertake a third and much more ambitious voyage, this time with five ships and several hundred men.

The plan was to follow Columbus' blueprint. This meant the establishment of colonies in the territories that had been discovered, with indigenous populations commonly enslaved. Importantly, the king must have

wanted Cabot to actually bring back something useful to the royal coffers. Tales of distant lands did not pay for the costly wars Henry was increasingly embroiled in, but hard cash did. Cabot was therefore under pressure to succeed. In May 1498, his fleet of ships left Bristol, Cabot still believing he had discovered a route to Asia, not the North American continent. What happened next is one of the great mysteries in the history of world exploration. It is known that one ship was damaged and turned back by the coast of Ireland. As to the rest—and John Cabot—their fate can only be surmised because of the lack of historical information.

It has been suggested Cabot could have died during the voyage, and that some or all of the ships returned to Bristol having not achieved very much. This may explain why so little evidence exists, but another reason could be that Henry, facing rebellions at home, had no time to concern himself with the fate of Cabot and those who went with him. It is known that the pension paid to Cabot by the king ended in 1499, suggesting Cabot died at sea. The Venetian's great expedition to follow up on his initial discovery seems to have ended in failure, however Henry's sponsorship of Cabot was nevertheless hugely significant.

It established England's claim to North America, which would be more firmly secured by new colonies created during the subsequent reigns of Elizabeth I (Virginia) and James I (Jamestown). If Cabot had not ventured out under the sponsorship of Henry VII, Spain may have sought to colonise land farther north, confident it had no competitors. If that had been the case, world history would have developed very differently.

Despite this, Cabot has never been as celebrated in America as Columbus. But that may be changing. Columbus' treatment of indigenous peoples has come under greater scrutiny lately. His reputation is tarnished, with many calling for the renaming of New York City's Columbus Circle and the removal of his statue from that prominent spot. Cabot may yet have his day in the sun.

HENRY VIII: THE KING AS SUBJECT

Hans Holbein paints the definitive royal portrait

Henry VII, Elizabeth of York, Henry VIII and Jane Seymour
Dated 1667, Remigius van Leemput, Haunted Gallery,
Hampton Court Palace, Royal Collection

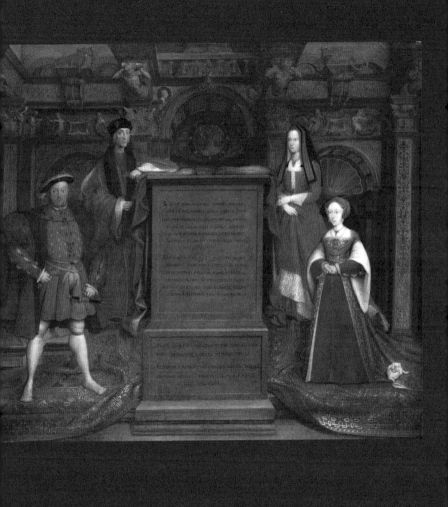

enry VIII (1491–1547) is one of the most famous monarchs in British history, infamous for his six wives, his girth and his reputation as a strong, yet often terrifying ruler. Most people shown a painting of a British monarch who lived hundreds of years ago would fail to recognise the subject, however a rare exception to this state of affairs is the image of Henry VIII. The credit for this goes to Hans Holbein the Younger, for many the greatest painter ever to work at court.

Holbein was born in Augsburg, in what is now Germany, in 1497, and learnt his art from his father (the Elder), a celebrated painter in his own right. Much of the Younger's life was spent in Basel, where he was associated with Erasmus, arguably the most celebrated scholar and thinker of the era. Holbein's portraits of Erasmus helped establish his reputation throughout much of Europe. In the 1520s, the artist arrived in England, where he was patronised by Thomas More, the great statesman and humanist.

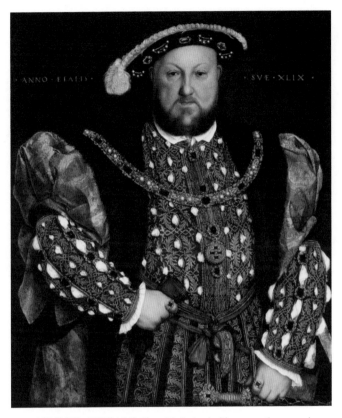

Henry VIII (1491–1547), 1540, Hans Holbein the Younger, oil on panel,
34.8 x 29.3 in (88.5 x 74.5 cm), Galleria Nazionale d'Arte Antica, Rome

Holbein's portraits were incredibly detailed and
lifelike, capturing the essence of his subjects in a way no
other artist could achieve. The demand for his services in
Europe was such that he left England in 1528 for Basel.
At home, he was treated as a celebrity and feted by the
authorities. However, the lure of London proved to be
too great, and he returned in 1532.

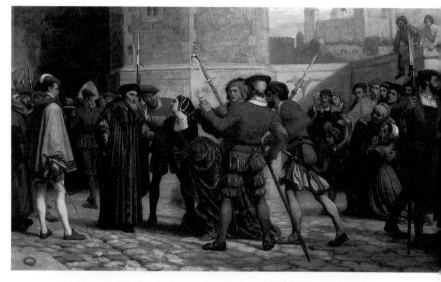

The Meeting of Sir Thomas More with His Daughter After His Sentence of Death, c. 1872, William Frederick Yeames, oil on canvas, 39.8 x 68 in (101.5 x 173 cm), private collection

The country he came back to was being torn asunder by Henry's religious reforms and the beginning of the English Reformation. Holbein's great patron, Thomas More, had once been close to the king, but now their relationship was rapidly deteriorating as the monarch sought to break with the Catholic Church. The tragic conclusion would take place in 1535 when More was executed for his continued refusal to sanction Henry's radical changes and condone the married man's lust for Anne Boleyn.

For some artists, the loss of a key patron would have been a disaster, but Holbein's skills were held in such high regard that his association with More was not

Anne Boleyn in the Tower of London, 1835, Édouard Cibot, oil on canvas, 63.9 x 50.9 in (162.5 x 129.4 cm), Musée Rolin, Autun, France

held against him. He secured the patronage of More's great enemies: Queen Anne Boleyn, at last the king's second wife, and Thomas Cromwell, architect of the Reformation.

Holbein's rise was confirmed in 1535 when he was appointed as Painter to the King. As such he was in a unique position to witness the dramatic goings on at the Tudor court, where he painted many of the main protagonists. Holbein, who resided in Maiden Lane, also regularly painted foreign merchants living in London, diplomats to the court and other wealthy people for whom a picture by the greatest artist then in England was much sought after.

In the mid-1530s, Henry's reign reached a crisis point, and Holbein could not escape becoming involved. More's execution in 1535 was followed a year later by that of Anne Boleyn—the woman whom Henry was so desperate to marry that he had forced his whole kingdom to break with the Catholic Church and been excommunicated by the pope.

Henry was also suffering from ill health (possibly syphilis), his legs covered in painful open sores that refused to heal. Rebellions against him began to break out from Yorkshire to Scotland, whilst a war in Ireland was draining the royal treasury. Despite having been married since 1509, the king still had no male heir to succeed him, and the two daughters he did have—Mary, by his first wife, Catherine of Aragon; and Elizabeth, by his second wife, Anne Boleyn—had been declared illegitimate on his own orders. It was hard not to conclude that Henry's reign had been a failure and that the good-looking Renaissance prince, so full of promise, had not reached his full potential as an ageing king.

Henry therefore needed Holbein to help him project a powerful image that would show his many enemies he was still a force to be reckoned with.

In 1537, the artist produced the most iconic image of Henry ever created in a mural depicting Henry's dynasty: his father, Henry VII; his mother, Elizabeth of York; and his third wife, Jane Seymour. Strategically placed in the Palace of Whitehall and measuring three metres by four, the wall painting dominated the privy chamber where it was located. The effect on visitors was dramatic, one writing it was so "lifelike that the spectator felt abashed, annihilated in its presence."

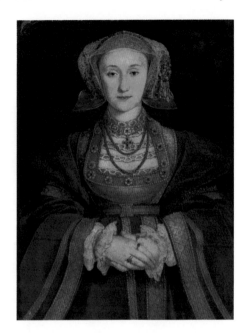

Portrait of Anne of Cleves,
c. 1539, Hans Holbein
the Younger, parchment
mounted on canvas, 25.6
x 18.9 in (65 x 48 cm),
Musée du Louvre, Paris

Sadly, the mural and palace were destroyed in
the fire of 1698, but not before many artists, including
Remigius van Leemput, had produced copies and stand-
alone paintings of Henry on his own that spread like a
propaganda virus throughout the kingdom and Europe.

Why was Holbein's depiction of Henry so
influential? The stance taken by the king in the painting
was radical, unashamedly masculine and defiant, with
Henry staring directly at the viewer in a way that was
highly unusual in royal portraiture in the early 16th
century. Holbein's preparatory sketch shows Henry
adopting a more orthodox pose, his face in three-quarters
pose (as Jane Seymour's face is depicted). It was probably
Henry who asked Holbein to change this, insisting on a
more confrontational look and posture. Holbein showed
Henry as he was: a huge bear of a man, with a jutting

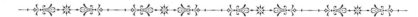

HENRY VIII ON HIS DEATHBED

King Edward VI and the Pope, c. 1575, unknown artist, oil on panel, 24.5. x 35.8 in. (62.2 cm x 90.8 cm), National Portrait Gallery, London

The picture above depicts Henry on his deathbed, pointing towards his successor, Prince Edward. Henry's dreams of establishing a great Tudor dynasty were just that. The sickly Edward VI would die just six years later, aged fifteen. Henry's daughters Mary and Elizabeth would both reign, but neither produced an heir.

Painted by an unknown artist during the reign of Elizabeth I, it is another example of Tudor Protestant propaganda, from the undignified position of the pope to the depiction (in the top right-hand corner) of Henry's troops demolishing symbols of Catholicism. ✦

cod piece, clenched fists and bling-covered body boasting necklaces, rings, diamonds and gold.

The mural was also a celebration. After the execution of Anne Boleyn, Henry quickly married Jane Seymour, who produced what Henry wanted more than anything else—a male heir. The country's celebration of the birth of Prince Edward (later Edward VI) was short-lived when Jane died a few weeks later from complications relating to the birth. In truth, Holbein's mural showed a living king surrounded by three ghosts.

Seymour's death would once again lead to Holbein becoming intimately involved in Henry's complicated world and even more complicated sex life. The king wanted to marry again, and with haste. So, he sent Holbein to the Protestant courts of Europe to paint portraits of the most eligible princesses available.

Holbein's portrait of Anne of Cleves convinced the king that he had found his fourth wife. However, the match proved to be a disaster when Henry came face-to-face with Anne upon her arrival in England. There was no sexual spark. "She was no better than a Flanders mare," he declared. And whilst he went through with the marriage, he soon had it declared invalid on the grounds it had not been consummated. Henry's adviser Thomas Cromwell fell from grace partially as a result of his role in recommending the marriage to Anne of Cleves, but once again Holbein survived the loss of another patron and was not punished for painting the portrait.

Holbein was at the height of his powers when he died in London in 1543, possibly from the plague. He was just forty-five. Henry would die four years—and two additional marriages—later.

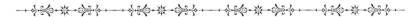

THE AMBASSADORS

The Ambassadors, 1533, Hans Holbein the Younger, oil on oak, 81.5 x 82.5 in (207 x 209.5 cm), National Gallery, London

The Ambassadors, which hangs in the National Gallery in London, is one of Hans Holbein's most famous paintings. It depicts two wealthy and educated young men at the Tudor court. At the left is Jean de Dinteville, 29, French ambassador to England.

To the right stands Georges de Selve, 25, Bishop of Lavaur.

Certain details in the work can be interpreted as references to contemporaneous religious and political divisions in England and Europe. On the top shelf, on which the two ambassadors

rest their arms, is a hodgepodge of misaligned astronomical instruments, indicating chaos in the heavens. On the shelf below, the broken lute string signifies discord and disharmony in the earthly civilized world. While the fully open Lutheran hymnal may be viewed as an endorsement of Christian unity, the mathematical textbook is partially open to a chapter on division. The painting's best-known feature is the distorted image of a human skull, a symbol of mortality, only revealed to the spectator's eye when seen from the side. Because Dinteville presumably commissioned the painting, this is an allusion to his personal motto: "Memento mori" ("Remember you will die"). Easy to overlook is the crucifix peeping out from the curtain in the painting's upper left corner.

Holbein painted *The Ambassadors* in 1533. That same year, Henry VIII quarreled with the pope over the Catholic Church's refusal to grant him a divorce from his first wife, Catherine of Aragon. This led to Henry's decision to create his own independent Church of England. As a result, these two Catholic ambassadors in Holbein's masterpiece found themselves in a helpless position, witnessing events unfold that they were unable to influence. ✦

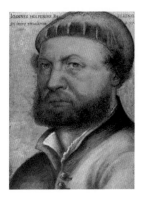

Self-portrait, 1542 or 43, Hans Holbein the Younger (1497/98–1543), color chalk, pen and gold, 12.5 x 10.2 in (32 x 26 cm), Uffizi Gallery, Florence

THE TRIAL OF CATHERINE OF ARAGON

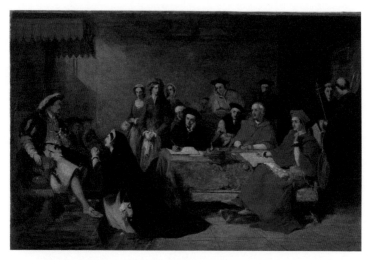

The Trial of Catherine of Aragon (1485–1536), 1846-48, Henry Nelson O'Neil, oil on canvas, 17.1 x 25.7 in (43.4 x 65.2 cm), Birmingham Museum and Art Gallery

Royal divorces are messy affairs, especially when played out in public as the divorce between Henry VIII and his first wife, Catherine of Aragon, was in 1529. The proceedings set the standard for royal reality shows to come. But at least Catherine —totally humiliated though she was—did not lose her head, as two of Henry's later wives did.

Henry Nelson O'Neil's painting, The Trial of Catherine of Aragon, 1846–48, captures the moment when the rejected queen fell to her knees during her divorce trial and made an impassioned, heartfelt plea to Henry. A previously loving husband, he now argued that their marriage was invalid, and that it was against the teachings

of Christ for a man to marry his brother's widow. In this case Catherine had been briefly married to Henry's elder brother Arthur before the latter's death aged just fifteen. Catherine countered that her marriage to the teenage Arthur had not been consummated and she had still been a virgin when she came to Henry's bed.

But what an unfortunate bed it turned out to be, cursed by miscarriages and stillbirths. After almost twenty-five years of marriage, there were no living male heirs. Only a girl, Mary, later Queen Mary I, survived, and that did not sit well with Henry. He demanded a legitimate male heir to secure the Tudor line (not a bastard like Mary, as he decreed her), and for that he needed a new wife, Anne Boleyn.

And so the climax came at the court in Blackfriars on June 21, 1529. It was an

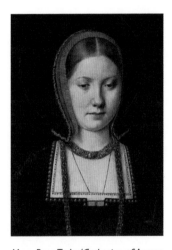

Mary Rose Tudor/Catherine of Aragon (1485–1536), c. 1514, Michel Sittow (c. 1469–1525), oil on panel, 11.2 x 8.2 in (28.7 x 21 cm), Kunsthistorisches Museum, Vienna

extraordinary day, the king and queen of England talking publicly about the sexual state of their marriage. It would not be the last time dirty royal laundry was aired in public. ✦

LADY JANE GREY: THE NINE-DAY QUEEN

History's footnote, art's tragic heroine

The Execution of Lady Jane Grey
1833, Paul Delaroche, oil on canvas, 96.9 x 117 in (246 x 297 cm),
National Gallery, London

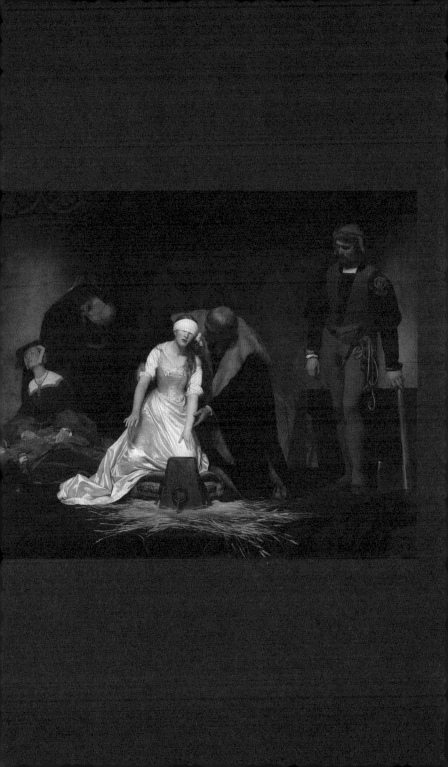

On February 12, 1554, a sixteen-year-old girl who had briefly been the queen of England spent the last morning of her short life in the Tower of London. Just before her execution, she would see her young husband of only a few months being walked to his death. She also knew her father was somewhere in the Tower, soon to suffer an equally tragic end.

Three hundred years later, Paul Delaroche's painting, *The Execution of Lady Jane Grey*, became instantly popular when it went on display in Paris in 1834 and was sold for a record sum to a Russian aristocrat. It captured the final moments of a pawn in the poisonous political world of the Tudor court.

The seeds of Lady Jane Grey's fateful life were planted at the moment of her birth. Her mother, Frances Grey, Duchess of Suffolk, was the daughter of Henry VIII's sister, so Jane had Tudor blood flowing through her veins.

When Henry VIII died in 1547, he left as his heir nine-year-old Edward VI. Edward was potentially a great king—cultured, educated and mature for his age. He was also born in the same year, 1537, as Lady Jane Grey, and her parents harboured ambitions of a marriage between the royal cousins.

However, these plans came to nothing when, in early 1553, the fifteen-year-old king fell ill. His condition steadily deteriorated until the royal physicians informed those closest to him that he was almost certain to die. It was a terrible blow to the king's supporters on the Privy Council led by the Duke of Northumberland. All their personal ambitions hinged on Edward, a staunch Protestant, continuing to reign. They feared that the next in line to the throne, Edward's half-sister Mary, was a Catholic zealot who would force the country to return to Rome.

Northumberland began to plot a way to ensure Mary did not succeed the dying king. Playing on Edward's fears that his religious reforms would be undone after his death, he convinced Edward to exclude Mary and his other half-sister, Elizabeth, from the line of succession so Lady Jane Grey would be heir to the throne. Then he had to find a way to secure his control over Jane so she would be queen in name only. Northumberland realised the best way to control Jane was to secure a marriage between her and his son Guildford. If she became queen, his son would become king.

Jane's parents were persuaded to agree to the match, although their daughter was hostile to it. By the standards of the day, Jane was remarkably well

educated, with a reputation for being independently minded. It is said her parents used to beat her on account of her wilfulness, but what is certain is that she was a committed Protestant—a feature that made her particularly attractive to Northumberland and his supporters.

Northumberland's plot to secure power progressed significantly when, in May 1553, Jane married Guildford in a lavish ceremony in London. Featuring jousting, banquets and theatrical performances in a grand house by the edge of the Thames, it must have seemed a joyous, optimistic event. However, many of the guests would become seriously ill through food poisoning, an ominous omen for what was about to unfold. According to legend, Northumberland had Edward kept alive through careful doses of arsenic—long enough to ensure a change to the king's will, but causing the fifteen-year-old king untold pain in his final days.

When Edward died on July 6, 1553, events unfolded quickly. Northumberland and other members of the Privy Council met with Jane, who was shocked to find out not only that the king was dead, but also that she had been elevated to the throne.

She would have been well aware that Mary in particular had always been popular with ordinary people. She would also have realised that she was a relative unknown, whose claim to the throne above the two daughters of Henry VIII was likely to meet with significant opposition. Unsurprisingly, when first told the news, Jane reacted by falling to the floor, crying and then announcing, "The crown is not my right and pleases me not. The Lady Mary is the rightful heir."

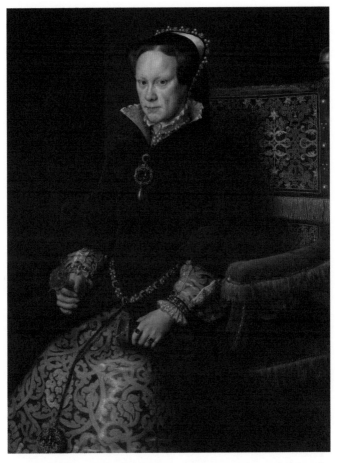

Mary I of England (1516–58), 1554, Antonio Moro, oil on panel, 42.9 x 33 in (109 x 84 cm), Museo del Prado

Her protestations fell on deaf ears; and her family, Northumberland and the Privy Council sought to consolidate her position by moving her to the Tower of London and publicly proclaiming her as queen.

THE STREATHAM PORTRAIT

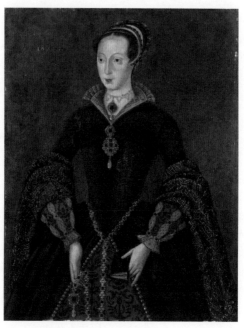

Lady Jane Grey, c. 1590–1600, unknown artist, oil on oak panel,
33.8 x 23.8 in (85.6 x 60.3 cm), National Portrait Gallery, London

The "Streatham" portrait, an oil on panel from the 1590s, is believed to be a later copy of a portrait of Lady Jane Grey. It depicts the young woman in Tudor dress holding a prayer book, with the faded inscription "Lady Jayne" or "Lady Iayne" in the upper left background. The three-quarter-length likeness was acquired by London's National Portrait Gallery in 2006. Research has thrown doubt on the sitter's identity, and the work is now thought to be part of a set of paintings of Protestant martyrs. If so, Lady Jane Grey is the only monarch since Henry VII not to have left behind an image from her lifetime. ✦

Londoners, most of whom were unaware Edward had even been ill, were shocked. Tensions began to rise as the public sensed a coup d'état had taken place, and the popular Mary had been cast aside.

The next few days would be among the most dramatic in the nation's history. The new queen, reluctant as she was, showed that despite her age she was strong-minded, refusing to agree that her new husband, whom she barely knew, would be given the title of king.

The decision, however, would quickly become irrelevant. Northumberland's meticulous plotting had failed in one critical aspect: Mary was still at large and building up her army in East Anglia. She wrote a stern letter to the Privy Council, making it clear that she was the true queen and Jane was a usurper—a threat that caused members of the Privy Council to question their support for Jane.

Northumberland quickly assembled a military force that left London in an attempt to defeat Mary, but it was too little, too late. As it became clear that the general public supported Mary's claim, his troops began to desert him. Back in London, the Privy Council quietly left the Tower, proclaiming Mary as their queen. Jane was left almost alone in the Tower. Her reign had lasted just nine days from the date of the public announcement of her succession.

Soon Mary arrived as queen in London to rapturous public acclaim. She began to take her revenge, starting with Northumberland who was beheaded in front of a baying crowd of 50,000 onlookers. Jane and her husband were forced to take part in what today

would be called a show trial and were condemned to death.

For a short while it seemed Mary would be merciful, postponing the death sentence. Everyone acknowledged that Jane was as much a victim of Northumberland's plotting as she was a beneficiary. She only had to avoid any more controversy and she would have lived. However, her father, a weak man whose life was punctuated by poor decisions, would make a final one. Fearful that Mary was going to return the nation to Catholicism and marry Prince Philip of Spain, he took part in a new rebellion against the queen. It forced Mary's hand, and she had to be seen to stamp out any opposition to her reign. The order was therefore given that Jane, her husband and her father were to be executed.

Jane took the decision bravely, refusing to condemn her father for his disastrous decision to take part in the rebellion that had secured her death. Kept in separate quarters within the Tower of London, Jane showed her independent mind to the very end, refusing a request from Guildford that they meet the night before they were to be executed, Jane being of the view that their meeting would only increase their misery and pain.

The next morning was bitterly cold. Jane saw Guildford being taken away for his execution. Shortly afterward, his corpse, carried back on a cart, caused her to cry out, "Oh Guildford, Guildford!" But she was soon on her way to the same site of execution, accompanied by her ladies in waiting and clutching her precious prayer book in which she had written farewell messages to loved ones.

A Catholic clergyman, whom Mary had sent to try and convince her cousin to convert to Catholicism, met Jane at the scaffold. She refused his efforts, telling the clergyman that she had been more bored by him than she was frightened by the prospect of her death.

Jane remained remarkably composed for a teenager about to be executed with an axe. She made a final, short speech and recited Psalm 51 before she knelt down in front of the executioner's block. The masked executioner asked for her forgiveness, which Jane gave, and then she was blindfolded.

Delaroche's painting captures what happened next as the blindfolded Jane felt for the wooden block but could not find it, her hands grasping at thin air. Beginning to panic for the first time, she shouted out, "What should I do? Where is it?" Sir Thomas Brydges, Lieutenant of the Tower of London, stepped forward to guide her hands and she calmed down, laying her head on the block. Her last words were, "Lord Jesus, into thy hands I commend my spirit!"

Within seconds the axeman separated Jane's head from her body. Her corpse lay on the scaffold for several hours, her blood staining the straw placed around the block. She was later buried in the Chapel of St. Peter ad Vincula within the Tower.

Paul Delaroche's romanticised depiction of Jane's execution is not fully accurate historically. Jane did not wear white, the axeman was masked and the execution took place outdoors (Delaroche's darkly lit picture appears to place events indoors). However, this dramatic painting amazed viewers in Paris when it was unveiled for the first time, striking a chord in a country that itself

had suffered from years of political instability and state-sponsored executions. It also sparked a renewed interest in Jane's story. In the mid-19th century, twenty-four other paintings depicting her were put on display at the Royal Academy in London.

Delaroche's version was later bequeathed to the National Gallery in London. But in the 20th century such historical paintings were regarded as old-fashioned. It was believed the painting was destroyed in a flood at the museum in 1928; however, it was miraculously rediscovered and restored in the 1970s, after being found hidden in the archives.

When it went back on view, it was as popular with English art lovers as it had been with the French populace. The image became the best-selling postcard in the National Gallery's shop. This popularity is significant because there is no authenticated image of Jane, despite several portraits that claim to be of her. One historian has described it as having an "overwhelming impact on modern interpretations of Jane," and indeed for many people Delaroche's painting, completed nearly three hundred years after the terrible events of 1553–4, remains the defining image of the Nine-Day Queen.

Queen Mary's victory would not last long, however. She died five years later, succeeded by her half-sister Elizabeth whose long reign (1558–1603) would relegate Jane's nine days on the throne to a footnote in the history books.

ELIZABETH I: GLORIANA

The Rainbow Portrait and the birth of MI5

The Rainbow Portrait
c. 1600–02, attrib. Marcus Gheeraerts the Younger or Isaac Oliver, oil on
canvas, 50.4 x 40.2 in (128 x 102 cm), Hatfield House, Hertfordshire

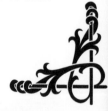

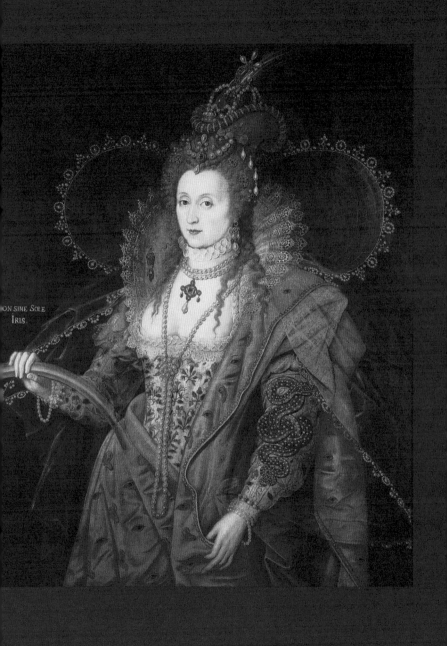

On a cold winter's day in February 1587, Mary, Queen of Scots, laid her head on the executioner's block at Fotheringhay Castle.

A small dog, previously concealed, ran out from beneath her skirt, and a crowd of around 400 people stared as the woman who had been queen of France, Scotland and (in her view) England prepared to die. She prayed that her cousin, Elizabeth I, spare her ladies-in-waiting, and that Britain and Scotland be returned to the Catholic faith.

The execution was even more gruesome than usual. The axeman failed to cut off Mary's head with a single blow, striking twice more to complete the deed. When he held up the head to show the crowd, he shouted, "God save Queen Elizabeth! May all the enemies of the true Evangel thus perish!" It is said that Mary was wearing a wig, and the executioner was left holding it in his grasp as her head came away, falling to the floor. The crowd collectively gasped, now seeing for the first time the queen's prematurely grey hair.

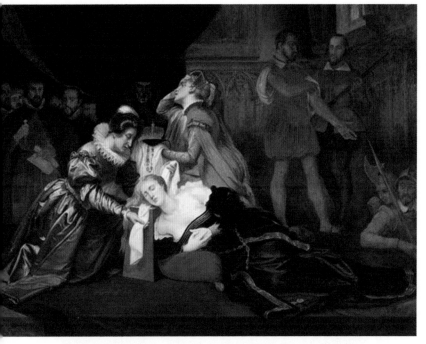

The Death of Mary Queen of Scots (1587), 1800s, Abel de Pujol (1785–1861), oil on canvas, 102 x 130.5 in (259.2 x 331.6 cm), Musée des Beaux-Arts de Valenciennes, France

How was the end of Mary's tragic life connected to arguably the most intriguing and mysterious portrait of any British monarch ever to be created?

The so-called *Rainbow Portrait* was painted c. 1600, just a few years before Queen Elizabeth's death. She was already in her sixties, near the end of a 44-year reign—a reign in which she had survived fourteen assassination attempts, countless plots, defeated the

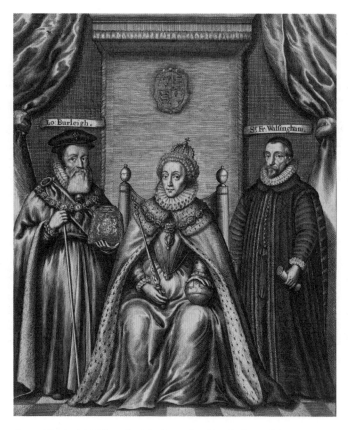

Queen Elizabeth I, William Cecil, 1st Baron Burghley, Sir Francis Walsingham,
early to mid-17th century, unknown artist, line engraving, 7.5 x 5.9 in
(19 x 15 cm), National Portrait Gallery, London

mighty Spanish Armada and outlasted all the men who
thought they could control her.

There are dozens of clues in the painting—a
masterpiece of Tudor allegory attributed to Isaac Oliver—

that help explain why Elizabeth died peacefully in her bed and not on the executioner's block like her cousin.

On her cloak are eyes and ears. On the left sleeve of her gown is a coiled serpent, and in her right hand she holds a rainbow beside a Latin inscription. But perhaps the most important reason for her longevity lies with the family who commissioned the painting. Today, the *Rainbow Portrait* hangs in Hatfield House in Hertfordshire. Elizabeth spent much of her early life in a house that once stood on the same site, and it was here that she was told that she had become queen following the death of her half-sister Mary I. Robert Cecil, 1st Earl of Salisbury, who came to own the land, built Hatfield House in 1611, and it is he who is believed to have commissioned the *Rainbow Portrait.*

Robert Cecil was the son of William Cecil, Elizabeth's most trusted adviser for nearly the whole of her reign. It was William Cecil, and later Francis Walsingham, principal secretary to the Queen, who created the world's first national intelligence network designed to keep Elizabeth safe from her enemies.

Why did Elizabeth need protection? Much of it had to do with religion. A Protestant, she had lived through the religious revolution of her father, Henry VIII, which had torn the country apart and pitted Catholics against Protestants. Catholic nobles, Jesuits and others who wished to return England to their faith plotted against Elizabeth throughout her reign, supported by money and resources from Catholic Spain and the Vatican itself. Catholic groups on the Continent were continuously sending coded messages across the Channel to their supporters in England.

Francis Walsingham, who became known as Elizabeth's spymaster, countered the threat by employing mathematicians to break codes, double agents to spy on their Catholic masters, and operatives to open sealed letters and read their contents without being discovered. He also had a team of dedicated torturers and executioners able to force secrets out of Catholic plotters, whose identities had been discovered after codes were broken.

For many Catholics, Mary, Queen of Scots, was their great hope. A Catholic, she had a legitimate claim to Elizabeth's throne because of her Tudor lineage: Her paternal grandmother, Margaret Tudor, was Henry VIII's sister. After falling foul of the aristocracy in Scotland, she was forced to abdicate and sought sanctuary with her cousin Elizabeth in England. Elizabeth kept Mary under house arrest for years. She realised Mary was a rallying point for her enemies but was concerned what the reaction would be if she had Mary executed.

Robert Cecil and Walsingham were, however, determined to catch Mary in the act of plotting against Elizabeth and thus destroy her. They finally succeeded when they intercepted messages sent between a group of plotters and Mary, effectively entrapping the Scottish queen into giving her consent to an assassination attempt on the English queen. It sealed Mary's fate and led to her being executed for treason. Several of the plotters caught corresponding with Mary were hanged, drawn and quartered—the most horrendous fate as it involved the victim being hanged until he was nearly dead, then revived before his private parts were cut off and intestines

pulled out and burned. The ordeal only ended when the prisoner was cut into four pieces.

Given that Robert Cecil commissioned the *Rainbow Portrait*, the symbols within it almost certainly reflect the role his family played in protecting Elizabeth. The eyes and ears suggest not only the queen's omniscience, but also that of her close advisers, the Cecils, who saw and heard everything. The snake is a sign of cunning and wisdom, appropriate given the Cecils' ability to see off plots—like Mary's—through subterfuge and code breaking.

There are many other symbols in the painting that would have been clearly understood by an educated person at the start of the 17th century. For example, the pearls worn by Elizabeth are associated with virginity. The embroidered flowers on her bodice have meanings, too. Pansies, from the French "pensées," symbolise thoughtfulness, while cowslips stand for the mystery of the Holy Trinity and honeysuckle for happiness and love.

Elizabeth's right hand holds a rainbow, and near it is the Latin motto, "Non sine sole iris," meaning, "There is no rainbow without the sun." Obviously, the queen is the royal sun, centre of everything, giving colour and vitality to the nation after a period of turbulence. The rainbow is also an allegory for peace.

One reason why the painting continues to fascinate and hold its secrets close is that even art historians throughout the years have debated its meaning. An alternative interpretation put forth by some is that the queen posed for the artist in the guise of Astraea, goddess of innocence in Greek mythology, her elaborate headdress and rich garb having been worn to a masque

or entertainment put on by Cecil in which Elizabeth appeared as the goddess. However, it seems likely Cecil commissioned the portrait as a way of celebrating his family's service to the queen by keeping her safe for so many decades. Whilst to the modern view some of the allegorical explanations can seem far-fetched, in the Elizabethan Age artists consulted books that set out common explanations for allegorical symbols. This would have appealed to Elizabeth who was known to enjoy a difficult puzzle. Perhaps Cecil intended this complex portrait to be admired by Elizabeth in particular, knowing she would examine and appreciate every detail.

In the painting, Elizabeth, who was in failing health, looks far younger than her real age. For years, the queen and her court had strictly controlled all official images of her, and those who failed to follow the rules were likely to see their artworks destroyed. One aspect of this control was the use of face patterns—officially sanctioned images of Elizabeth's face—which artists had to follow.

The result was a monarchy that carefully managed its own image, particularly important for a female ruler who had to portray strength and majesty in an age when many men refused to believe women were their equals.

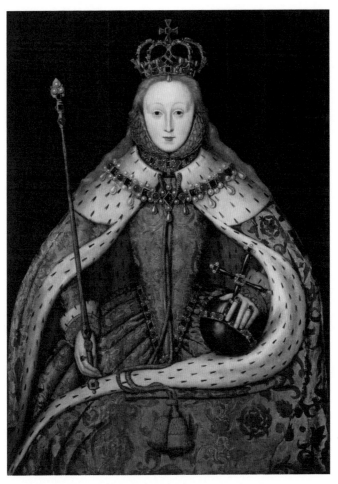

Queen Elizabeth I, c. 1600, unknown English artist, oil on panel,
50.1 x 39.3in (127.3 x 99.7 cm), National Portrait Gallery, London

THE MURDER OF RIZZIO

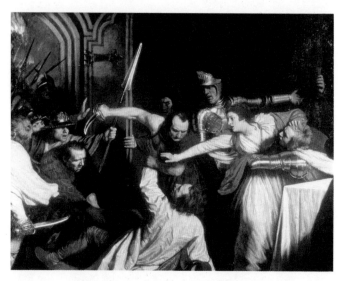

The Murder of Rizzio, 1787, John Opie (1761–1807), oil on canvas, 94 x 113 in (239 x 287 cm), Guildhall Art Gallery, London

On March 9, 1566, Mary Stuart, Queen of Scotland—seven months pregnant—sat down to dinner in the Palace of Holyroodhouse in Edinburgh. Her companion that night was her private secretary, David Rizzio. The meal did not end well.

The daughter of Scottish King James V, Mary had succeeded him when she was just six days old. At sixteen, she was queen of France when her husband, Francis, the dauphin, ascended to the French throne. But when Francis died a year later, she returned to Scotland, a chaotic, violent place, where she made the first of many bad choices: She married her first cousin, Henry Stuart, Lord Darnley.

Initially a love match, it soon soured. Darnley was a drunken womanizer, who seethed with jealousy as Mary spent more time with Rizzio, a charming, intelligent Italian and a superb musician.

Rumours spread that Rizzio, not Darnley, was the father of Mary's unborn child.

And so the stage was set for the momentous dinner, captured so cinematically by painter John Opie in 1787.

Darnley suddenly entered the room, accusing Mary of adultery. The Earl of Ruthven appeared wearing armour. Rizzio, realising something terrible was happening, hid behind the pregnant queen. Ruthven pulled out a pistol whilst other aristocrats rushed in. A knife was held to Mary's belly to keep her from intervening.

The men began to stab Rizzio. He was wounded fifty-six times before being thrown down a staircase and stripped naked. His mangled corpse was hastily buried.

Mary gave birth to a son a few weeks later, but she never forgave Darnley, and the marriage collapsed. A year later, an explosion destroyed the house in Edinburgh where Darnley was staying, and he was found outside, apparently strangled to death. Almost everyone in Scotland believed Mary was involved in the murder.

Mary would marry her third husband, the Earl of

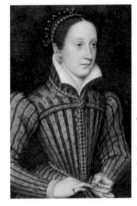

Mary, Queen of Scots (1542–87), c. 1558, François Clouet, Royal Collection

Bothwell, just a few months after Darnley's murder. That relationship, like the others, did not last. Mary would later be forced by the Scots aristocracy to flee Scotland, and seek refuge with her cousin, Elizabeth I of England. However her plot to take Elizabeth's throne resulted in her execution.

Ironically perhaps, Mary's son, James VI of Scotland, succeeded Elizabeth I when she died in 1603. As James I of England, he sat on the throne of the queen who had ordered the assassination of his mother. And if the rumours were true and Rizzio, not Darnley, was the father of James, then Rizzio was the father of a king of England and grandfather of another king, Charles I. ✦

THE HOUSE OF TUDOR

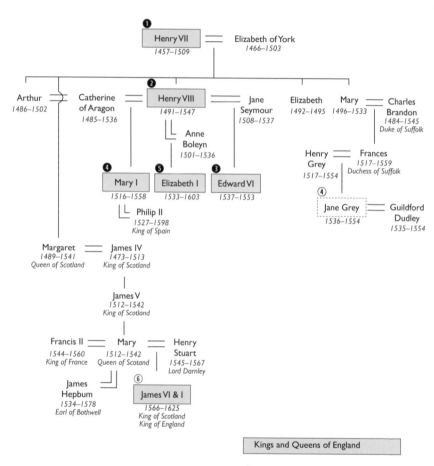

1 Henry VII
1457–1509

Elizabeth of York
1466–1503

Arthur
1486–1502

Catherine
of Aragon
1485–1536

2 Henry VIII
1491–1547

Anne
Boleyn
1501–1536

Jane
Seymour
1508–1537

Elizabeth
1492–1495

Mary
1496–1533

Charles
Brandon
1484–1545
Duke of Suffolk

4 Mary I
1516–1558

Philip II
1527–1598
King of Spain

5 Elizabeth I
1533–1603

3 Edward VI
1537–1553

Henry
Grey
1517–1554

Frances
1517–1559
Duchess of Suffolk

(4) Jane Grey
1536–1554

Guildford
Dudley
1535–1554

Margaret
1489–1541
Queen of Scotland

James IV
1473–1513
King of Scotland

James V
1512–1542
King of Scotland

Francis II
1544–1560
King of France

Mary
1512–1542
Queen of Scotand

Henry
Stuart
1545–1567
Lord Darnley

James
Hepbum
1534–1578
Earl of Bothwell

(6) James VI & I
1566–1625
*King of Scotland
King of England*

Kings and Queens of England

1 Henry VII (1457–1509): Chapter II

2 Henry VIII (1509–1547): Chapter III

3 Edward VI (1547–1553)

4 Mary I (1553–1558): Chapter IV

5 Elizabeth I (1558—1603): Chapter V

(6) James I (1603–1625, the House of Stuart)

HENRY FREDERICK STUART: THE FORGOTTEN PRINCE

The best king England never had

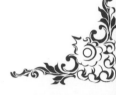

*Henry Frederick (1594–1612), Prince of Wales, with
Sir John Harington (1592–1614), in the Hunting Field
1603, Robert Peake the Elder, oil on canvas, 79.5 x 58 in
(201.9 x 147.3 cm), The Metropolitan Museum of Art, New York*

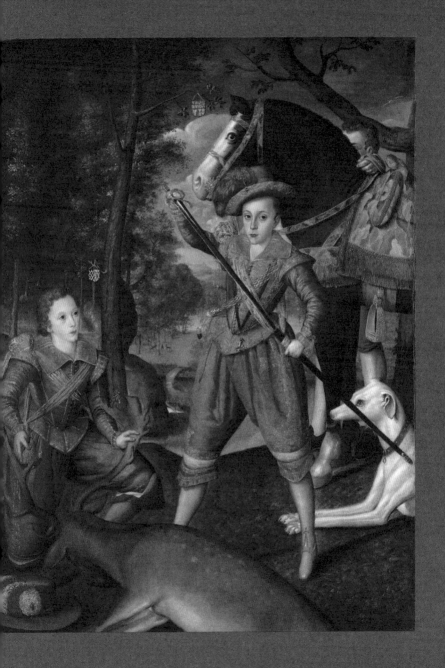

i t is a long way from The Metropolitan Museum of Art in New York to Windsor Castle in England, but a painting in the Met of a young prince delivering the coup de grâce to a wounded stag connects the two.

Dating from 1603, it is the work of Robert Peake the Elder. The figure wielding the sword is nine-year-old Prince Henry Frederick Stuart (1594–1612), at the time the eldest son and heir of King James I of England.

Holding the deer's antlers is his childhood friend, Sir John Harington. Every part of the picture carries a message. For example, Harington is an aristocrat, but displays deference to the prince by kneeling, his hat laid on the ground; Henry's clothes contain more gold thread than Harington's, and his belt displays St. George slaying the dragon, symbolic of a monarch defending his kingdom.

A near identical painting by Peake can be found in the Queen's Drawing Room in Windsor Castle. Dating from c. 1605, this one has another boy—Robert Devereux, 3rd Earl of Essex—holding the antlers. Within just seven years of this second painting, Henry would

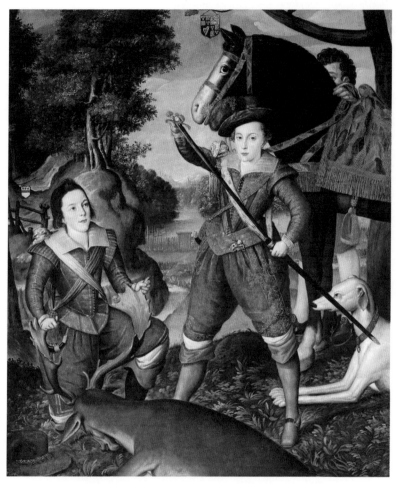

Henry, Prince of Wales with Robert Devereux, 3rd Earl of Essex in the Hunting Field, c. 1605, Robert Peake the Elder, oil on canvas, 75 × 65 in (190.5 × 165.1 cm), Queen's Drawing Room, Windsor Castle, Royal Collection

be dead and the fortunes of his family, and those of Harington and Devereux, would be changed forever.

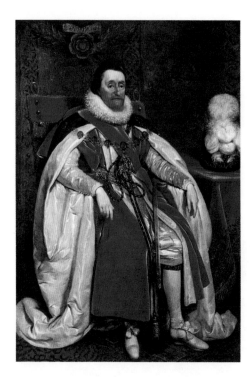

King James I of England and VI of Scotland, 1621, Daniel Mytens, oil on canvas, 58.5 x 39.6 in (148.6 x 100.6 cm), National Portrait Gallery, London

Ask random strangers to identify the subject of either painting, or tell you any facts about Prince Henry, and they will almost certainly struggle. However, during his lifetime, the prince was one of the most admired figures in Europe.

Henry was born in Scotland in 1594, the eldest child of King James VI of Scotland and Queen Anne of Denmark. James' reign in Scotland was a troubled one. As in many countries in Europe, the impact of the Reformation in Scotland was still causing bitter divisions amongst the population. A rebellious aristocracy had forced James' mother, Mary, Queen of Scots, to abdicate her throne, and James and his family were under constant threat of assassination and kidnapping.

Whilst James was a well-intentioned man, highly educated and, for some, the embodiment of the Renaissance Prince, his judgement was often flawed. One of the many enemies he made was his own wife, angry that her husband had chosen to take young Henry away from her care and have him educated under the protection of the Earl of Mar in Stirling Castle. It was for good reason the king wore a stab-proof vest under his tunic.

Henry received a rigorous education in Scotland from the best tutors in Latin and Greek, military tactics, horsemanship, throwing the pike, dancing and languages. James even wrote an instruction manual on how to be a good king—the *Basilikon Doron*—for his son.

James' struggles in Scotland were matched by the frustration he endured waiting for Queen Elizabeth I of England to anoint him as her successor. A childless spinster, Elizabeth had strong reservations about James' abilities to govern and waited until she was on her deathbed in 1603 to confirm that James should succeed her.

A triumphant James VI of Scotland quickly prepared his family to escape south to England, where he would claim the throne of both England and Ireland, becoming James I.

Initially, many English people welcomed the Scottish Stuart family, believing them to be a desirable change after the stagnant final years of Elizabeth's reign. However, James managed to antagonise several important groups, particularly Catholics who felt he reneged on promises of religious toleration. One group of militant Catholics attempted to blow up James, Henry and the

rest of the royal family when they visited Parliament in November 1605. The famous Gunpowder Plot failed, but for young Henry it was yet another confirmation of the brutal world into which he had been born.

Many English aristocrats regarded Scotland as a barbaric place, and resented James' followers who had arrived with him and were rewarded with important positions of influence at court. Nor was James' cause helped by gossip about his effeminate mannerisms and apparent infatuations with good-looking young men at court.

Against this background, nine-year-old Henry arrived in England. He was sent to live and be educated at Nonsuch Palace in Surrey, joined by a carefully chosen group of young aristocrats who were expected to form the prince's inner circle of trusted companions. This group included John Harington and Robert Devereux, explaining why they feature in the two paintings by Robert Peake of Henry hunting the deer. Their aristocratic families, who hoped to secure long-term influence with the king and his heir, strategically placed each boy with Henry.

Henry had to mature very quickly at a time when a boy officially became an adult upon reaching fifteen. Although only nine, he hired Robert Peake as his official artist, aware of how important it was to control how his image was presented to the world. Peake's career as a royal painter began with Elizabeth I, and he would go on to paint all the leading members of the Stuart dynasty up until his death in 1619. In this era, portraits of the royal family were skilfully used as political and diplomatic tools, and paintings of Henry were sent to the leading

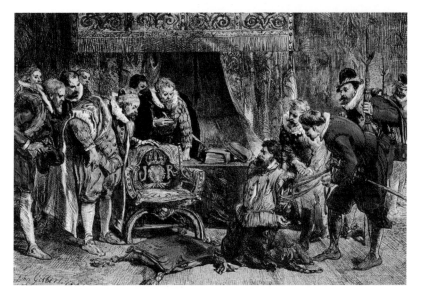

Guy Fawkes being brought before King James I after the discovery of the Gunpowder Plot, 1605, wood engraving, 1861, after Sir John Gilbert

royal houses of Europe as part of James' efforts to secure a suitable bride for his son.

Peake's picture of Henry taking part in the hunt was revolutionary. Never before had a royal been portrayed undertaking such a vigorous activity. Art historian Roy Strong described it as "a quite unprecedented innovation in royal portraiture." The depiction of a nine-year old boy killing a stag is a hugely powerful one, conveying to the world that this was a strong prince who meant business.

By his teens, Prince Henry based himself in St. James's Palace in central London and Richmond Palace to the west. Charismatic, physically confident and ambitious, Henry impressed everyone who came into

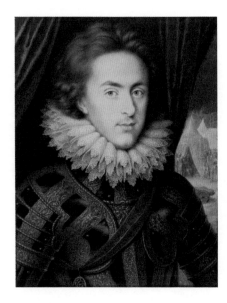

Henry Frederick, Prince of Wales (1594–1612), c. 1610, Isaac Oliver (c. 1565–1617), watercolour on vellum laid on card, 5.2 x 3.9 in (13.2 x 10 cm), Royal Collection

his orbit, attracting some of the most ambitious men of the age. The king, who spent half the year absent from London obsessed with hunting and his latest favourite, encouraged Henry to develop his own junior royal court. James seemed detached from the obligations of ruling as a monarch, whilst his ambitious son seemed eager to grab the reins of power as soon as he was able.

This inevitably led to tensions. James insisted on peace even though many men of influence wanted a more aggressive foreign policy, particularly against the Catholic Spanish state. Such men gravitated toward Henry who supported reform of the navy and the pursuit of wars in Europe against those who opposed the Protestant cause.

With James out of sight much of the time, Henry commissioned masques and other entertainments that kept the aristocracy enthralled, with grand costumes and dramatic works designed and written by famous figures such as Inigo Jones and Ben Jonson. When elevated to the rank of Prince of Wales, Henry also used his substantial new income to indulge in his passion for art—the first royal to display such enthusiasm.

The teenage prince spent a fortune acquiring artworks of the late-Renaissance era. This became the foundation of the royal family's art collection—later known as the Royal Collection. Today, the collection contains around one million pieces, including Peake's painting of the hunt featuring young Devereux.

Henry was also fascinated by the sea and explorers, providing money and patronage to those seeking to find the elusive Northwest Passage and others who were determined to establish a British presence in North America. With respect to the latter, Spain claimed that continent for itself, and vigorously opposed the Virginia Company of London's settlement of Jamestown that was founded in 1607.

Henry, as a shareholder in the company, made sure it obtained the services of some very capable individuals. One of the prince's men was Sir Thomas Dale who arrived in Jamestown in 1611 to find it on the verge of collapse. Dale helped turn around Jamestown's fortunes and sailed up the James River to found a new settlement which he named for the prince—Henricus. Cape Henry and Henrico County in Virginia remain as small clues to the influence of a largely forgotten prince. If Jamestown had failed, Britain may have given up on colonising

America, and Spain or France could have dominated that continent. Arguably, Henry's support for the Virginia Company changed the course of world history.

By 1612, Henry was desperate to see the world, but his status restricted him from doing so. He had to make do with travel stories relayed back to him by Harington and Devereux who were busy exploring Europe. Meanwhile James was finalising plans to marry Henry to a strategically useful daughter of a European power when disaster struck. The prince became seriously ill.

It began in Richmond on a hot summer day. Henry, having "filled himself with fish, with oysters both raw and dressed with fire," retreated to a nearby river to ease his indigestion. He spent hours in the water, and it may have been here he picked up an infection. Despite the intense summer heat, he then set off on a journey on horseback that saw him travel nearly 100 miles over a two-day period. Henry must have thought he was invincible, but over the next few weeks he became increasingly tired—a feeling that was novel to him. He even had to stop taking his customary dawn walks with childhood friend John Harington, too tired to get out of bed.

When Henry moved from Richmond back to St. James's Palace, the state of his health slowly declined, although the young prince still tried to defy his body by playing tennis and undertaking many other activities. But he was fighting a losing battle. Possibly suffering from typhoid fever, the prince was eventually confined to his bed in St. James's Palace. Slowly it became evident to a

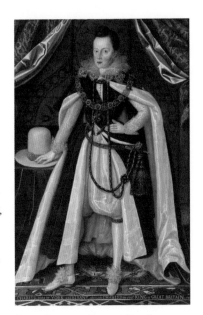

*Charles, Duke of York and Albany
(The future Charles I of England),*
1611, Robert Peake the Elder
(c. 1551–1619), oil on canvas,
57.4 x 36.8 in (146 x 93.5 cm),
The Weiss Gallery, London

shocked royal family that their glorious heir—the future
of the Stuart dynasty—was dying.

Desperate to save him, King James permitted his
son to suffer the barbaric medical treatments of the day.
This involved repeatedly being bled, having holes drilled
in his head, and a slaughtered chicken held to the soles
of his feet. However, when it became clear the situation
was hopeless, the dying prince met with his parents
and younger siblings, Charles and Elizabeth, for the last
time. No one knows what final words were exchanged,
but it is known that little Charles brought his beloved
elder brother a gift of one of Henry's favourite pieces:
a sculpture of a horse that Henry had acquired from
the Medici collection. Soon after, the prince died on
November 6, 1612. In an instant everyone in St. James's
Palace knew that the next king would not be Henry IX,
but Charles I.

Two thousand mourners followed Henry's funeral cortege on its slow journey to Westminster Abbey. Weeping Londoners thronged the streets to say goodbye. A wooden effigy of Henry, dressed in his robes and topped with a lifelike waxwork head of the prince, lay on top of the coffin. It helped stir up deep emotions amongst onlookers, a witness writing of "some weeping, crying, howling, wringing of their hands, others halfe dead … passionately betraying so great a losse with rivers, nay with an ocean of teares."

Brave little Charles, bandy-legged, frail and just twelve years old, led the funeral procession. His parents stayed away, devastated by this bitter blow to their plans to secure the Stuart dynasty. After the funeral, someone stole the head of Henry's effigy, and today the battered wooden remains of what was left behind are kept at Westminster Abbey, a poignant reminder of the prince sometimes described as the best king England never had.

And what became of Harington and Devereux, the two boys in Peake's paintings who expected to spend their lives serving Henry? When the prince died, Harington lost his royal protector and became overwhelmed by the debts of his aristocratic family, dying just two years after Henry. Centuries later one of his descendants, the actor Kit Harington, would find international fame playing a prince in the television series *Game of Thrones*. Kit Harington is also descended from John Catesby, leader of the Gunpowder Plot.

For his part, Devereux sided with Parliament during the Civil War, and so the boy who kneeled before Henry in Robert Peake's painting would later help secure the death of the prince's younger brother, Charles I.

Ironically perhaps, Devereux was hunting one day in 1646 when he suffered a stroke, dying soon after.

CHARLES I: THE THREE FACES OF A KING

Sir Anthony Van Dyck's masterpiece that wasn't meant to be

Charles I (1600–1649)
1635–before June 1636, Sir Anthony Van Dyck (1599–1641),
oil on canvas, 84.4 x 99.4 cm, Royal Collection

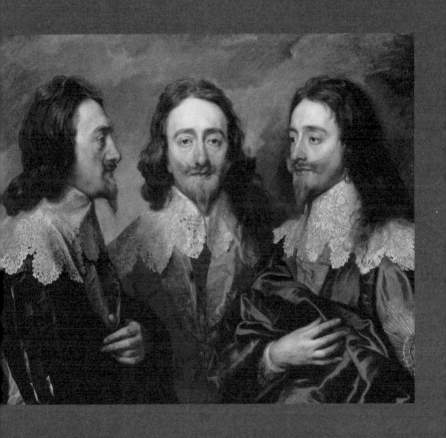

I n 1635, one of the greatest painters in Europe, Sir Anthony Van Dyck, began work on a portrait of Charles I (1600–1649). There was nothing unusual in this. Van Dyck's extraordinary artistry had long established him as the king's official court painter, and the results were hung in nearly every royal palace. However, this portrait was different. Its purpose was not to celebrate the king in paint or further Van Dyck's reputation, but to be a model for a completely new work of art created in marble by another artist in a faraway city.

That city was Rome, where Gian Lorenzo Bernini, a pioneer of the Baroque style, had established himself as the finest sculptor since Michelangelo. With prominent commissions from Pope Urban VIII and Pope Alexander IX, Bernini had established himself as the Vatican's favourite artist.

Charles I had been fascinated by art since he turned up unannounced at the Spanish court in his twenties and had seen the works of the great Renaissance masters, such as Titian. Since then he had been trying to

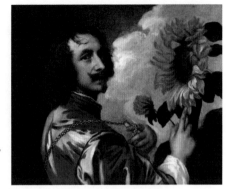

Self-portrait, after 1633,
Anthony Van Dyck
(1599–1641), oil on canvas,
22.9 x 28.7 in (58.4 x 73.0 cm),
private collection

catch up with the rival courts of Europe, which had long
collected great works of art.

Charles believed his authority was derived from
God, and he wanted to project an idealised image
of himself to his subjects. In an era when the king
was fighting the forces of Parliament and many other
institutions, royal propaganda was a dark art, and Charles
was its master.

However, there was a problem. Charles was king
of a Protestant country, and the greatest sculptor in
Europe was unquestionably Bernini, who lived in Rome
and whose patrons were the popes. Tensions between the
Vatican and Protestant countries such as England were
high, so it was not as simple as just paying for Bernini to
travel to London.

Bernini had been producing exceptional marble
busts of prominent Catholic cardinals and popes since
he was twenty, so why would the Vatican allow him to
create something that could only reinforce the authority
of a Protestant king who denied the Vatican's unique
relationship with God? Pope Urban VIII made the official

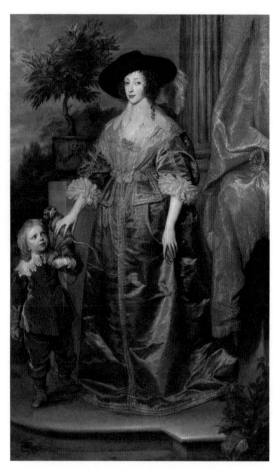

Henrietta Maria and the dwarf, Sir Jeffrey Hudson, 1633, Sir Anthony Van Dyck, oil on canvas, 86.6 x 53.1 in (220 x 135 cm), National Gallery, Washington, D.C.

position clear when he said to Bernini, "You are made for Rome, and Rome for you."

Luckily for Charles, a rare exception could be made. His wife and queen, Henrietta Maria of France, was a Catholic. She was also the goddaughter of Pope Urban VIII. Whilst this caused Charles no end of problems normally—many of his staunchly Protestant subjects were hostile to the existence of a Catholic as queen of a Protestant nation—it helped in the case of securing Bernini's services.

Henrietta Maria asked the Vatican's permission for Bernini to execute a bust of Charles, and the pope agreed. It was a diplomatic move, a gift from the pope who still hoped that Charles might convert to the Catholic faith. But there was a catch: Bernini could not leave Rome. He was too valuable to the pope, and the risk of allowing him to move, albeit temporarily, to a Protestant country where the monarch spent a fortune on artists was considered too great.

This created a practical problem as Bernini was used to meeting his subjects in person, but the pope and Charles were men accustomed to getting their own way. Charles turned to Van Dyck for a solution.

The Flemish painter was almost certainly influenced in his solution by an existing painting in the king's collection, *Portrait of a Man in Three Positions* by the Italian artist Lorenzo Lotto that dated from c. 1530. By copying Lotto's composition, Van Dyck would be able to provide Bernini with enough detail to produce a bust of Charles.

It is not recorded how Van Dyck felt about the commission, but he must have discussed it in detail with Charles. The king spent a considerable amount of time at the Dutchman's house by the river Thames, even paying for a wooden causeway that would allow him easier access to the artist's studio there.

Van Dyck was used to producing paintings designed to hang in the most prominent places in the great royal palaces of the land. These not only helped Charles convey an image of regal power, but advanced Van Dyck's reputation, enabling lucrative commissions from other patrons. To produce a painting of Charles

that was not intended to be seen by anyone other than Bernini, and could only help further that artist's reputation rather than Van Dyck's, must have been galling.

Van Dyck clearly decided he would produce something that made a statement about his own skills and that would be noticed by those in Rome. He added more detail than was strictly necessary. For example, the variety of colours, fabrics and lace patterns would matter little to a sculptor working in marble, but details like these showed off the painter's own skills to full effect. As to the king's hair, worn longer on the left-hand side, it reflected court fashion. The result was a superb painting, far better than it needed to be given its intention.

When Van Dyck was finished, Charles wrote to Bernini asking him for "our portrait in marble, after the painted portrait which we shall send to you immediately." Thomas Baker, High Sheriff of Suffolk, was entrusted with bringing the painting to Rome. When it arrived, Bernini must have begun to work quite quickly, although he disliked not working from real life. It is said that Bernini, when he saw the king's haunted expression, sensed that Charles had had a premonition of the terrible fate that awaited him.

In July 1637, Bernini's finished bust arrived in England after a slow journey from Rome. It was taken to the royal palace of Oatlands outside London, where Henrietta Maria presented it to Charles. He was delighted with the work, and a grateful queen sent Bernini a diamond worth £800.

The bust attracted controversy in a superstitious age. Some of Charles' opponents criticised it for being

a blatant attempt by the pope to convert the king to the Catholic faith. It was even suggested that the imperfections in the marble would remain until this conversion took place.

Another story arose that, when the bust was once brought out into a garden to be viewed, three drops of blood appeared on the face, leaving stains when they were wiped off. This was thought to represent the civil wars that would devastate England, Scotland and Ireland in the 1640s.

Charles ignored these portents of disaster. For a few short years, the bust by the most famous sculptor in the world had pride of place in the king's art collection. Charles even wanted Bernini to produce a companion piece of Henrietta Maria, but the king's obsession with art was about to be rudely interrupted by the English Civil War. The bust of Henrietta Maria was never produced, and Charles would be executed in 1649.

Bernini, safe in Rome, would outlive Charles by three decades. Van Dyck was less fortunate, dying in 1641 in London. He was just forty-two and at the height of his artistic power.

The subsequent history of Bernini's bust and Van Dyck's painting is complicated and also poignant. In Rome, Bernini's family kept the painting of Charles long after the sculptor died. It was eventually sold to an art dealer in the early 19th century and bought by George IV in 1822 for 1,000 guineas. Why was George so keen to acquire the painting of Charles I that served as the model for another work of art? One reason was to fill a gap in the royal art collection because Bernini's bust was no more.

Cromwell Lifting the Coffin-Lid and Looking at the Body of Charles I, 1831,
Paul Delaroche (1797–1856), oil on canvas, 90.5 x 118.1 in (230 x 300
cm), Musée des Beaux-Arts de Nîmes

After Charles was executed and to raise money, the
Commonwealth under Cromwell permitted the bust to
be sold by art dealer Emmanuel de Critz, who described
it as "the king's head in white marble done by Bernino at
Rome priced £400." At the Restoration in 1660, Charles
II recovered the famous bust of his father. However,
Bernini's masterpiece was destroyed in the great fire of
1698 that burnt down Whitehall Palace.

Today, by a quirk of fate, it is Van Dyck's
superb painting that is famous, whilst Bernini's work is
something only read about in books. Van Dyck's instinct
to do more than was strictly necessary turned out to be a
good one.

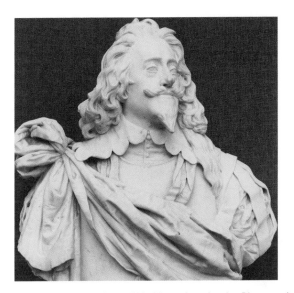

Charles I (1600–1649), c. 1700–50, attributed to Jan Blommendael (c.1650–1699), marble, 86.7 cm high (excluding base/stand), Grand Vestibule, Windsor Castle, Royal Collection

As with many lost royal treasures, there are "ghostly" reminders of Bernini's bust of Charles. What is believed to be a copy of the original bust by English sculptor John Bushnell (1636–1701), dating from 1675, is in the art collection of Compton Verney in Warwickshire. The Royal Collection also contains a bust of Charles attributed to Jan Blommendael which may be a copy of Bernini's original, but this has been disputed. It was bought by Queen Elizabeth II and is at Windsor Castle.

In a final twist to the story, Thomas Baker, the man believed to have taken Van Dyck's painting to Bernini, sat in Rome for the great sculptor. The result

was a very rare bust of an English Royalist, which can be seen today in the Victoria & Albert Museum in London. Given Charles I's ambitions, it is ironic that the man who carried Van Dyck's picture on a difficult journey ended up being immortalised by a Bernini sculpture and not the king himself.

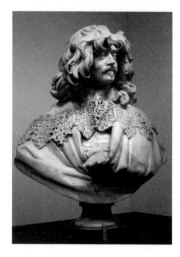

Bust of Thomas Baker, 1638, Gian Lorenzo Bernini, marble, 32 in (82 cm), Victoria and Albert Museum, London

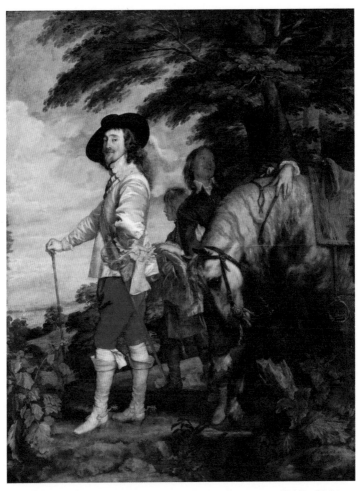

Charles I at the Hunt, c. 1635, Anthony Van Dyck, oil on canvas, 104.7 x 81.5 in (266 x 207 cm), Musée du Louvre, Paris

THE FIVE ELDEST CHILDREN OF CHARLES I

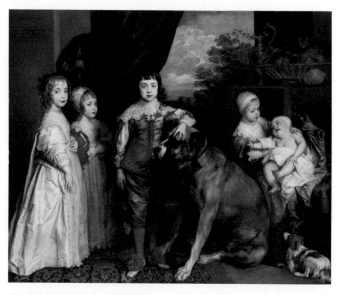

The Five Eldest Children of Charles I, 1637, Sir Anthony Van Dyck (1599–1641), oil on canvas, 64.3 x 78.3 in (163.2 x 198.8 cm), Queen's Ballroom, Windsor Castle, Royal Collection

Sometimes paintings don't tell the whole truth. As happy as Anthony Van Dyck depicted the five eldest children of Charles I and his queen, Henrietta Maria of France, their fates were anything but. The portrait was painted in 1637, just five years before the Civil War that would almost destroy the Stuart dynasty.

Prince Charles, eight, the eldest boy and heir to the throne, stands centre stage with his hand on the head of a mastiff. Of the five, he fared best, regaining the throne for his family in 1660 and ruling until

his death in 1685, one of the most loved monarchs in British history.

Princess Mary, standing at the far left of the group, was only six at the time of the portrait. At nine, she married Prince William of Orange and was shipped off to the Dutch Republic. She escaped the English Civil War, but was widowed at nineteen when her husband died of smallpox. Ten years later, she returned to London only to tragically succumb to smallpox herself.

Next to Mary is Prince James, who succeeded his brother as James II. In the 17th century, it was the custom that little boys were "unbreeched," meaning they wore gowns up to around eight. At five, James had three years to wait before he was allowed to wear trousers (or breeches). His life should have been as successful as that of his elder brother,

but it wasn't. After succeeding Charles II in 1685, he failed to accept the limitations of royal power and, as a Catholic, was insensitive to the Protestant forces ranged against him in Parliament, the aristocracy and the army. He was dethroned in 1688.

Elizabeth, two, cuddling her baby sister Anne in Van Dyck's portrait, was captured by Parliamentary forces and imprisoned from the age of six until her death at fourteen. Anne would die aged three.

Charles I commissioned the painting for £100 and kept it in his breakfast chamber. However, under Cromwell's rule it was one of many fine pieces of art sold off to pay creditors. Charles II recovered it for his collection, but James II either sold it or gave it away. In 1765, George III bought it back. Today, it hangs in the Queen's Ballroom in Windsor Castle. ✦

WINDSOR BEAUTIES: THE KING'S FAVOURITES

Sir Peter Lely paints mistresses of King Charles II

Barbara Villiers, Duchess of Cleveland (c. 1641–1709)
c. 1663–65, Sir Peter Lely (1618–80), oil on canvas, 49 x 39.9 in
(124.5 x 101.4 cm), Hampton Court Palace, Royal Collection

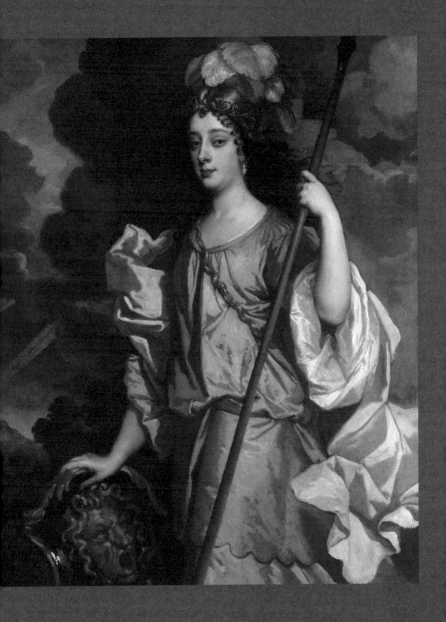

in the early 1660s, King Charles I's official painter Sir Peter Lely (1618–1680) received an unusual commission from Anne Hyde, Duchess of York, the first wife of the king's brother James. Anne wanted Lely to paint the most beautiful women of the royal court, and he set about his task with gusto. Eleven ladies would sit for the painter, and today ten of those portraits remain in the Royal Collection, where they can be viewed together at Hampton Court Palace.

Whilst Lely set about completing his commission, an up-and-coming man named Samuel Pepys was writing his diary. A senior figure in the Navy Office, he mixed with members of the royal court and was privy to all the gossip that whirled around London in the late-17th century. He would record his impressions of many of the women immortalised by Lely, a group that would become known to history as the Windsor Beauties because for many years the paintings were kept at Windsor Castle.

The lives of the individual Windsor Beauties were full of drama. Two are said to have been killed by poison, whilst others were royal mistresses. One, born a

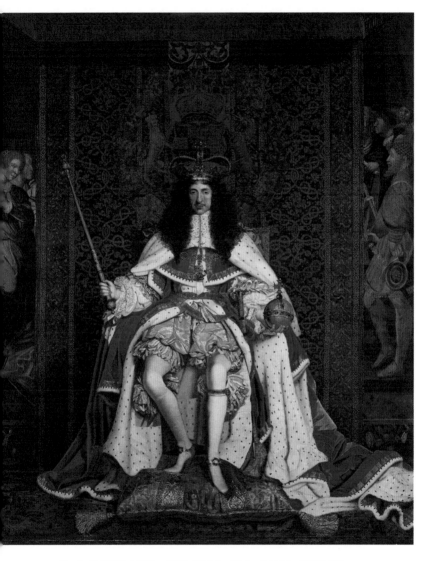

Charles II (1630–1685), c. 1671–76, John Michael Wright (1617–94), oil on canvas, 111 x 94.2 in (281.9 x 239.2 cm), Throne Room, Palace of Holyroodhouse, Royal Collection

commoner and hated by many at court, would give birth to two daughters who would eclipse all the Windsor Beauties by becoming queens.

The fact that Lely was asked to paint the Beauties at all was representative of the great change that had taken place in England. For years, the Puritans under Oliver Cromwell had sought to stamp out anything that was deemed frivolous. Theatres were closed and prohibitions placed on everything from women wearing makeup to children playing soccer on a Sunday.

After Cromwell's death in 1658, Charles II reclaimed the throne for the House of Stuart in 1660. This period, called the Restoration, saw Charles reverse many of the Puritan reforms. The result was perhaps the most scandalous, licentious court in history, with the moral tone set by a king who fathered a dozen illegitimate children and had countless affairs. Charles' only rival as a serial philanderer was his brother the Duke of York (later James II).

The most notorious of the Windsor Beauties was Barbara Villiers, also known as Lady Castlemaine and later the Duchess of Cleveland. A married woman, she was for many years the king's favourite mistress, famed for her violent temper and hold over the monarch. Despite the country's finances being in peril, he diverted substantial sums of money to her, whilst she used her position as de facto queen to secure even more illicit funds through taking bribes and even spying.

When Charles II was persuaded to marry Catherine of Braganza, a devout Catholic and member of the Portuguese royal family, a conflict between his new bride and Villiers was inevitable. The new queen

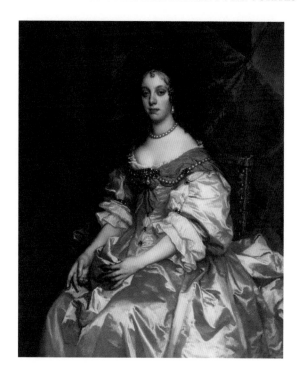

Catherine of Braganza (1638–1705), c. 1663–65, Sir Peter Lely (1618–80), oil on canvas, 49.4 x 40.4 in (125.4 x 102.7 cm), Throne Room, Palace of Holyroodhouse, Royal Collection

mistakenly believed she and Charles could enjoy a loving, intimate marriage. However, Charles was incapable of being faithful.

The Bedchamber Incident summed up what life was like for a woman—even a queen—at the royal court of the House of Stuart. It began when Charles asked Catherine to accept Barbara Villiers as a Lady of the Royal Bedchamber. This prestigious position meant the king's mistress would be in day-to-day contact with the queen. Unsurprisingly, the queen refused.

The ruthless side of Charles was then revealed to his wife. He sent her Portuguese servants back to their homeland, leaving the queen—young and unsophisticated after living much of her life in a convent—alone.

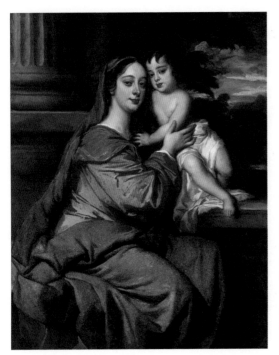

Barbara Villiers, Duchess of Cleveland with her son, probably Charles FitzRo as the Virgin and Child, c. 1664, Sir Peter Lely (1618–80), oil on canvas 49 1/8 in. x 40 1/8 in (124.7 x 102 cm), National Portrait Gallery, London

When she was tricked into meeting Villiers for the first time at a public function, the queen had an emotional breakdown, suffering a terrible nosebleed before fainting.

Eventually the queen gave in, but the marriage was never the same. For years Catherine suffered the humiliation of Villiers attending to her during the day, then sleeping with the king most nights of the week. It would get worse, much worse, as the queen failed to produce an heir to the throne, suffering several miscarriages. To add to Catherine's torment, Villiers had five healthy children with the king, her pregnant figure a constant reminder to the queen of her own bad luck.

The goings-on at court were the talk of the town, and Samuel Pepys in his diary lamented how the king

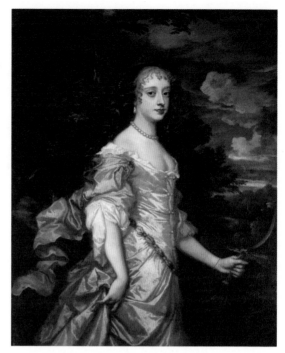

Frances Stuart, Duchess of Richmond (1648–1702), before 1662, Sir Peter Lely (1618–80), oil on canvas, 49.5 x 40.4 in (125.8 x 102.7 cm), Hampton Court Palace, Royal Collection

was unable to concentrate on any serious business, too taken up with his beautiful but scheming mistress.

He wrote of "[the king's] dalliance with my Lady Castlemaine being public, every day, to his great reproach" and how "the King sups at least four or five times every week with my Lady Castlemaine; and most often stays till the morning with her, and goes home through the garden and all alone privately."

Pepys also recorded how "I was told that my Lady Castlemaine hath all the King's Christmas presents, made him by the peers, given to her, which is a most abominable thing; and that at the great ball she was much richer in jewells than the Queen and Duchess put both together."

Like most men of that era, the artist Lely found Villiers a captivating woman, and he painted her many times. One portrait is among the most scandalous portraits of the Restoration period.

It depicts Villiers and her son Henry, the illegitimate son of King Charles, as the Madonna and Child. Villiers was officially married and had several lovers other than the king, so adopting the character of the Virgin Mary no doubt caused eyebrows to be raised. How the queen, a pious Catholic, reacted when she saw the picture is unrecorded, but it must only have caused her yet more misery.

However, every royal mistress has only a limited time in the sun, and another of the Windsor Beauties was about to replace Villiers in the king's affections. Pepys recorded the beginning of the great change in his diary. In Whitehall, he saw the queen and her ladies, walking, "talking and fiddling with their hats and feathers, and changing and trying one another's by one another's heads, and laughing. But it was the finest sight to me, considering their great beautys and dress, that ever I did see in all my life. But above all, Mrs Stewart in this dress, with her hat cocked and a red plume, with her sweet eye, little Roman nose, and excellent taille, is now the greatest beauty I ever saw, I think, in my life …" Pepys believed the king had noticed Mrs. Stewart too and "is the reason of his coldness to my Lady Castlemaine."

Lely's portrait of Frances Stewart captures her when she was still a teenager, and at about the time she arrived at court and Pepys spotted her walking with the queen and the other ladies of her entourage. Like the king,

Pepys began to fantasise about Frances Stewart, "fancying myself to sport with Mrs Stewart with great pleasure."

Suddenly, Barbara Villiers had a rival for the title of most beautiful woman in the land. Charles' interests were stirred immediately, and he became infatuated with the young Frances. When the queen contracted smallpox and almost died, many at court speculated that Charles— after a suitable period of mourning—would want to marry Frances. Barbara Villiers was worried. If the queen was replaced by Frances, then she would lose her position at court and with it all the riches and attention she had become accustomed to.

Villiers initially tried to exclude her rival Frances from her famous soirées and house parties, but when that did not work, she decided to follow the old adage of keeping her friends close and her enemies closer.

Pepys, as ever, had his ear close to the ground and watched the situation unfold. In his diary he recounted how "my Lady Castlemaine ... had [Frances Stewart] to an entertainment, and at night began a frolique that they two must be married, and married they were, with ring and all other ceremonies of church service, and ribbands and a sack posset in bed, and flinging the stocking; but in the close, it is said that my Lady Castlemaine, who was the bridegroom, rose, and the King came and took her place with the pretty Mrs. [Stewart]."

A mock marriage between two of the prettiest women of Charles' court, with the king sneaking in at the last moment, was, on the face of it, harmless fun. But the stakes were much higher as the mistresses of the king could be rewarded with titles, estates and annuities

that would enrich not just themselves but generations of their descendants.

It was assumed by many that Frances was pretty, but not terribly clever. "It would be difficult to image less brain combined with more beauty," Count de Gramont remarked. Frances was a teenager who liked to play hide-and-seek and build houses of cards, all the while pursued by not just the king but many other courtiers who wished to be credited with taking her to their beds.

Pepys would observe in his diary "how loose the Court is, nobody looking after business, but every man his lust and gain; and how the King is now become besotted upon Mrs Stewart, that he gets into corners, and will be with her half an houre together kissing her to the observation of all the world."

The king was well into his thirties, with a wife and several illegitimate children, so to modern eyes his infatuation with the teenage Frances seems odd. Whilst Pepys believed the king was having an affair with Frances, most people now believe she never went as far as the king's bedchamber. In fact, she would break the king's heart when she suddenly eloped with the Duke of Richmond, an almost unparalleled example of a young woman at court spurning the advances of the monarch. Frances had no doubt seen how the king's mistresses were treated as they got older and were replaced by younger women. Seeking to escape this fate, Frances jumped before it was too late.

Like Pepys, Lely, painter of the Windsor Beauties, was able to observe all these scandalous events at first hand. He was a survivor, having worked for Charles I

and then Cromwell, before joining the Restoration court of Charles II.

Lely was regularly criticised for portraying women in an idealised, unrealistic way, and indeed many of the Windsor Beauties could pass for sisters. The sleepy-eyed look so associated with Villiers became the template for female beauty, a styling that Lely carried to his other pictures his other pictures

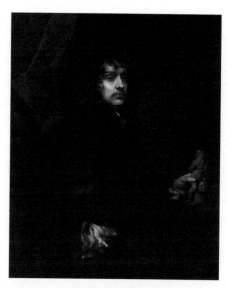

Peter Lely (1618–80), self-portrait, c. 1660, oil on canvas, 42.5 x 34.5 in (108 x 87.6 cm), National Portrait Gallery, London

regardless of what the subjects really looked like. His portraits of the Windsor Beauties made them famous outside the confines of royal circles, and copies were made and widely circulated. The celebrity status of the Windsor Beauties has raised comparisons with the Most Beautiful Women lists compiled by men's magazines today.

Frances Stewart, after escaping the king's attentions, was eventually forgiven by Charles and returned to court. She would pose as the model for mythical Britannia, and as such would appear on coins for several hundred years.

Barbara Villiers was replaced as the king's principal mistress in around 1670 by Louise de Kéroualle. Villiers

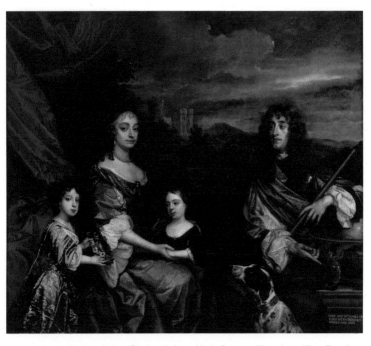

James II, when Duke of York with Anne Hyde, Princess Mary, later Mary II and Princess Anne, c. 1668–85, Sir Peter Lely (1618–80), oil on canvas, 66.4 x 76.4 in (168.6 x 194.0 cm), Royal Collection

would die when she was sixty-eight, having had many more lovers after Charles pushed her aside. One of her descendants was Diana, Princess of Wales.

Of all the ladies who sat for Lely, the one who was historically the most significant was Anne Hyde, Duchess of York, the woman who commissioned the Windsor Beauties. Whilst she was the daughter of one of the most senior statesmen in the land, she was regarded as a commoner. When she married the king's brother James, many aristocrats were appalled by such a union

and actively sought to have the marriage ended. Anne would survive this, but remained unpopular with many factions at court; she also had to live with her husband conducting numerous affairs of his own. Anne would die from cancer when she was just thirty-seven, and James would soon remarry. However, Anne's legacy was her daughters Anne and Mary, each of whom would sit on the throne as queen after Charles died without an heir and their father, James II, was forced out of England during the Glorious Revolution of 1688.

WILLIAM OF ORANGE AND JAMES II: A BATTLE ROYAL

Portraying victory and defeat

The Death of Frederick, 1st Duke of Schomberg, at the Battle of the Boyne, 1st July 1690, 1800–1899, after Benjamin West (1738–1820), oil on canvas, 21 x 29 in (53.3 x 73.7 cm), National Trust, Mount Stewart

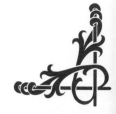

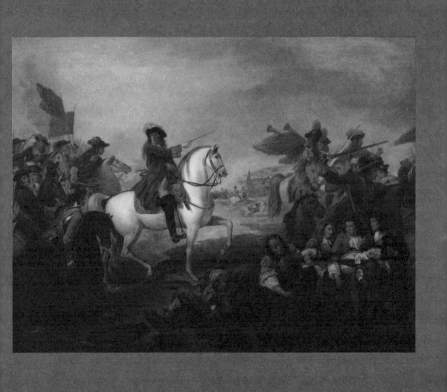

The history of Britain has often been shaped by great battles, although many Britons would struggle to name more than a handful, and of that handful few evoke much emotion given the passage of time. However, there is an exception. A small battle that took place in Ireland in July 1690 continues to stoke controversy and divide certain communities to this day.

This is evident when, on July 12 each year, thousands of people set out on marches in up to twenty towns and villages across Northern Ireland to celebrate the Battle of the Boyne. In a modestly sized town such as Limavady, with a population of around 12,000, the celebrations can attract 3,000 marchers and 70 bands, nearly all affiliated to dozens of Orange Order lodges.

Many of those marching carry banners that portray a king on a white charger, an image derived from a painting of the battle that was produced by the celebrated Anglo-American artist Benjamin West in 1788. The king was William of Orange, a Dutch Protestant fighting a Catholic monarch who had just been forced from the throne of England, Scotland and Ireland. But

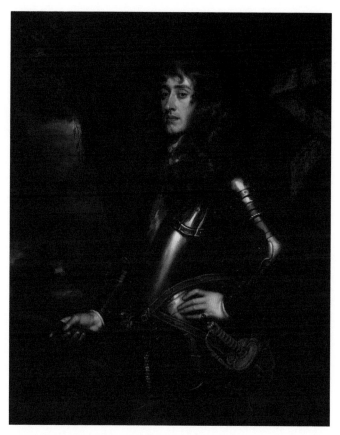

James VII & II (1633–1701) when Duke of York, c. 1665, Sir Peter Lely (1618–80), oil on canvas, 49.6 x 40.3 in (126.1 x 102.3 cm), Chamber, Palace of Holyroodhouse, Royal Collection

what was this Dutchman doing in Ireland, and why do so many people still celebrate his victory hundreds of years later?

To understand the significance of July 12 requires some knowledge of William's opponent that day on the

banks of the River Boyne: King James II. As a member of the Stuart dynasty, James had succeeded Charles II, his elder brother, when Charles died in 1685 without a legitimate heir.

Charles II was a popular monarch, healing many of the divisions caused by the Civil War that had led to the execution of his father, Charles I. However, James had few of his brother's skills of diplomacy. He was also incredibly stubborn and a Catholic in an age when England's ruling order was staunchly Protestant. Before he became king, James had reluctantly agreed to the marriage of his daughter Mary to his nephew William of Orange. William was Protestant and, as Prince of Orange, was the leader, or "stadtholder" of the Dutch Republic. By agreeing to the union, James had unwittingly sealed his fate.

As James began to rule over his kingdom, his support for Catholicism and winding back many anti-Catholic laws created a groundswell of opposition against him. Many influential noblemen and politicians could stomach this as James had two Protestant daughters by his first wife, Anne Hyde, one of whom was destined to succeed him on the throne.

But then, dramatically, the political landscape changed when James' second wife, the devoutly Catholic Mary of Modena, unexpectedly gave birth to a boy, also named James and now next in line to the throne. The king's opponents began to plot to overthrow him, many believing the ageing Mary had not even given birth to the boy, and that the royal couple had smuggled an orphaned baby into the birth chamber.

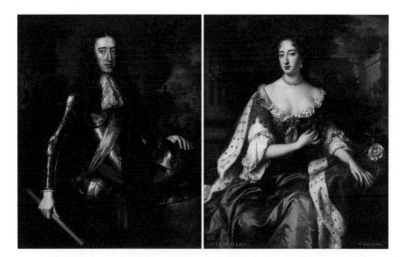

Left: *William III (1650–1702) when Prince of Orange*, 1685, Willem Wissing (1656–87), oil on canvas, 49.1 x 40.4 in (124.6 x 102.5 cm), Royal Collection

Right: *Mary II (1662–94) when Princess of Orange*, c. 1686–87, Willem Wissing (1656–87), oil on canvas, 49.5 x 40.3 in (125.8 x 102.3 cm), Royal Collection

But if the king was forced from the throne, who could succeed him? The obvious Protestant candidate was William of Orange, already married to James' daughter and a strong military leader who had fought against the armies of Catholic France and its allies all his adult life.

With the ruling elite of England seeking a foreign leader to depose a Stuart king who had been legitimately crowned as monarch, the situation was a delicate one. In mid-1688, a group of seven aristocrats secretly left London and visited The Hague in the Dutch Republic to plead their case with William personally.

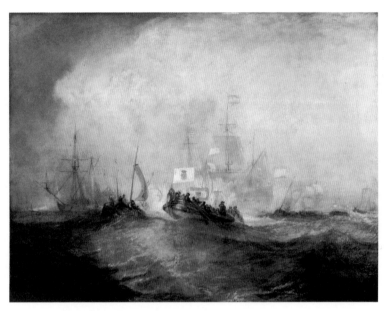

The Prince of Orange, William III, Embarked from Holland, and Landed at Torbay, November 4th, 1688, after a Stormy Passage, 1832, Joseph Mallord William Turner (1775–1851), oil on canvas, 35.5 × 47.2 in (90.2 × 120.0 cm), Tate Collection

William and Mary must have agonised over the implications of the plan to overthrow their family, and risk everything on a military invasion of an island that had only rarely been conquered. But once William made up his mind, he was determined. In November 1688, he led a vast invasion fleet comprising over 400 ships and 40,000 men across the English Channel, landing in Devon.

When James learnt of the invasion, he was defiant, and prepared to lead his own army against the Dutch

invaders. But his grasp on power was slipping away, evident when many of his army officers deserted him to join the other side. Even the king's other daughter, Anne, joined her sister Mary in abandoning her father's cause. Bitter, James realised his position was hopeless, and, in December 1688, he fled with his queen and young son James to France and into exile.

Whilst under the protection of Louis XIV, James was humiliated even further when William and Mary were crowned as joint rulers. His effort to regain his lost throne by force began almost immediately when he arrived in Ireland with an army in 1689, hoping to galvanise the population who—unlike the population in England—were largely Catholic and therefore his natural supporters. James hoped if he could secure Ireland, he could use it as a base from which to invade England.

But William of Orange wanted to smash James' resistance once and for all. In June 1690, he landed in Ireland with a huge army and began marching down to James' stronghold of Dublin. At the River Boyne, about thirty miles north of that city, William found James' army blocking his way.

The opposing forces were broadly divided along sectarian lines. William's army comprised Irish Protestants and soldiers from England, Scotland, Germany, Holland and Denmark. By contrast, the Jacobite army was made up of Irish Catholics, supplemented by French and Swiss troops.

Matters were complicated by the fact that Louis XIV was in a dispute with the Vatican, with the odd result that the pope supported Protestant William of

Orange in his conflict with Catholic James and the French king, who was funding James' army.

There was almost no battle at all. The day before, the sickly, asthmatic William was scouting along the course of the river when he stopped to have a picnic in full view of the Jacobite army on the other side. An enemy artillery crew spotted him and fired, killing one officer and wounding William in his shoulder. William coolly observed, "Ce boulet est venu bien pres. Ce n'est rien." ("The ball came close enough, but it's nothing.")

The Jacobites started cheering, for a moment believing they had killed William, but their joy was short-lived. Had they been right, a Dutchman's death by a river in rural Ireland would have changed the course of British history.

William, blessed by good luck, showed himself to his troops to calm their nerves. By contrast, as the battle loomed, James was overcome by anxiety and indecision, and despite years of experience as an active soldier, seemed unable to command effectively. Worried he would be outflanked, he began to order many of the artillery pieces and baggage be sent back to Dublin, ready for a retreat the next day.

On July 1, the armies prepared to fight in the heat of a summer's day. At dawn, William's army advanced, trying to cross the River Boyne at a number of places. With a huge advantage in artillery pieces, the bulk of the Williamite army—around 24,000 troops—crossed at a place called Oldbridge. Wading into the river up to their chests, they fought their way up the bank on the other side.

Against them were just 8,000 Jacobite troops and cavalry. Around 1,000 members of the cavalry charged to try and destroy William's best soldiers, the elite Blue Guards from Holland, but the veteran soldiers withstood the onslaught. After about four hours of fighting, the Jacobite army crumbled and began to flee.

William led more troops across the river, displaying great bravery. When one of his own soldiers mistook him for a Jacobite and pointed a pistol at his head, William calmly asked him, "What, are you angry with your friends?"

It was this moment, William crossing the river on a glorious white charger, that Benjamin West captured in his painting. West, who had a considerable reputation for his dramatic history paintings, knew his audience and what it wanted. He did not let historical accuracy get in the way of telling a good story, as this painting proves.

In reality, William, leading the reserves rather than the front line of the attack, was almost certainly riding a chestnut-coloured horse, and he probably had his arm in a sling due to the wound inflicted the day before. Furthermore, whilst crossing the river, William's horse became stuck in the mud, and the king had to dismount, suffering a severe asthma attack. A soldier in his army saved William from drowning and carried his commander to the riverbank to recover.

None of this is hinted at in West's painting. The artist's choice of a white horse was symbolic—possibly meant to show William as an almost godlike figure, his steed seemingly floating on the water of the Boyne as opposed to becoming mired in the dark mud underneath.

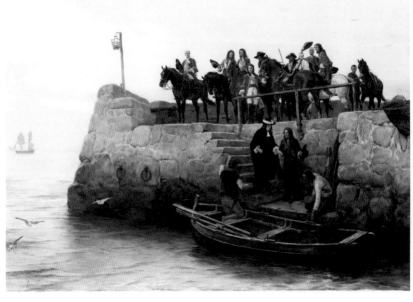

A Lost Cause: Flight of King James II after the Battle of the Boyne, 1888, Andrew Carrick Gow (1848–1920), oil on canvas, 46.5 x 59.5 in (118.1 x 151.1 cm), Tate Collection

West's fictionalised portrayal had an almost instantaneous impact becoming, at least for supporters of William's cause, the defining image of the Boyne victory.

Significantly on the day of the battle, James stayed a few miles away, a decision that did little to strengthen the morale of his men. As news arrived that his army was crumbling, he ordered a full retreat. Never again in British history would two rival claimants to the throne lead armies into battle against each other.

Within a few hours, James was back in Dublin. With William marching on the city, he decided to abandon both his army and Ireland. An 1888 painting by Andrew Carrick Gow captures the dismal moment when James, forsaking his ambitions, fled. Gow, best known for his historical paintings and portraits, here shows James (in black) with his head bowed, being helped down the steps of the harbour at Kinsale on the Irish coast. His supporters are left behind, whilst a rowing boat prepares to take him out to a French ship on the horizon, which would return the leader of the Jacobite cause—and the last Catholic monarch of England, Scotland and Ireland—to a life of exile on the Continent.

Many of his followers in Ireland were disgusted that James had left them to their fate, and he became known as Séamus an Chaca, or James the Shit.

In the years that followed the battle, supporters of the Protestant cause in Ireland began to form Orange lodges named for William. During the 18th century, Orangemen organised marches to celebrate the defeat of James and other acts of defiance under "King Billy." The marches were important in demonstrating the loyalist community's strength and continued support for British rule (hence the term "loyalist").

By contrast, the largely Catholic republican movement that wanted to end British rule over Ireland, formed their own groups and organised marches. Tensions arose when Orange parades marched through Catholic districts and vice versa—issues that continue to this day.

During the 19th century in particular, many thousands of supporters of the Orange movement

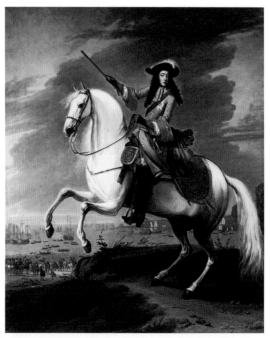

William III Landing at Brixham, Torbay, 5 November 1688,
1688, Jan Wyck, oil on canvas, 62 x 52 in (157.5 x 132.1 cm),
National Maritime Museum, Greenwich, London

emigrated to far-flung places around the world. When
they arrived, they often set up new Orange lodges and,
as a result, the victory of "King Billy" in 1690 is still
celebrated in places such as America, Canada and New
Zealand. Other British cities where Irish immigration was
significant—for example, Glasgow and Liverpool—also
host July 12 marches.

If you are wondering why the marches take place on July 12 when the Battle of the Boyne was on the first day of that month, the answer has been subject to some debate, but one explanation is that the re-dating of events took place in the mid-18th century when the old Julian calendar was replaced by the Gregorian version throughout the British Empire.

If you ever see an Orange parade on July 12, look out for banners and flags portraying "King Billy" on his white charger, just as Benjamin West imagined him.

BONNIE PRINCE CHARLIE: THE GREAT PRETENDER

Allan Ramsay's lost portrait of the prince

Prince Charles Edward Stuart (1720–88)
1745, Allan Ramsay (1618–80), oil on canvas, 12 x 10 in (26.8 x 21.8 cm),
Scottish National Portrait Gallery

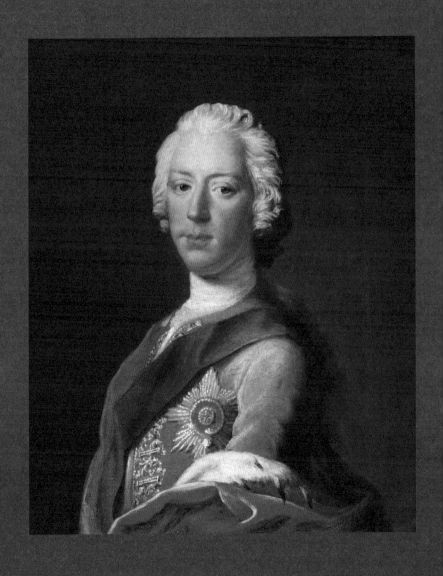

O n April 16, 1746, two armies faced each other on the moorland of Culloden in the northeast of Scotland. On one side was the army of Charles Edward Stuart—grandson of Stuart King James II, a Catholic and better known as Bonnie Prince Charlie—that had just a few months before threatened to capture London and overthrow the ruling monarch of Great Britain, King George II.

Comprised largely of battle-hardened Highlanders, Charles' army squared up to the Hanoverian king's troops, led by his son the Duke of Cumberland, or—as he would become known—the "Butcher." Charles' advisers told him not to fight Cumberland on the boggy ground of Culloden, but he ignored their advice. As a result, when his feared Highland warriors began their famous charge against the king's men, the soft ground slowed them down, making them vulnerable to musket fire. Although they smashed into the front line, their energy had been sapped.

Over the next hour, Charles' brave warriors were destroyed, the survivors mutilated and murdered where

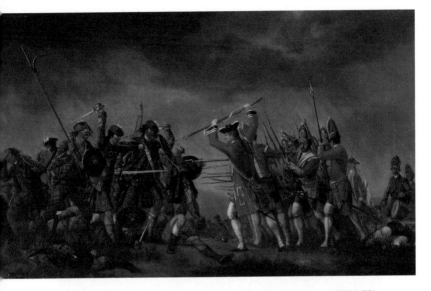

The Battle of Culloden, c. 1745–85, attributed to David Morier (1705?–70), oil on canvas, 23.8 x 39.2 in (60.5 x 99.5 cm), Palace of Holyroodhouse, Royal Collection

they lay. It would prove a bitter, final defeat for Bonnie Prince Charlie and the uprising that had begun during the summer of 1745.

Amidst the slaughter, Charles was whisked away, his supporters aware that the king's forces would be desperate to capture him. Not far away, a baggage cart carrying the prince's personal possessions was also pulled away at speed. Amongst these possessions was said to be a prized portrait of the prince by Scotland's greatest painter. However, in the chaotic aftermath of the battle, the baggage cart disappeared, presumed looted. The portrait also disappeared, although its story was not yet done.

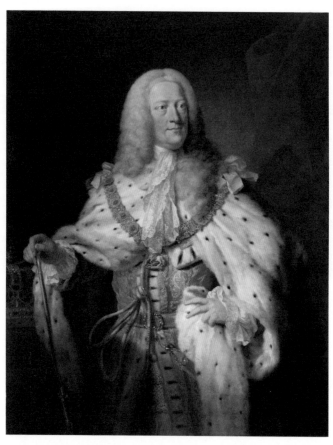

George II (1683–1760), before July 6 1757, John Shackleton,
50.6 x 40.5 in (128.5 x 102.9 cm), Ambassadors' Entrance, Buckingham
Palace, Royal Collection

In his mid-twenties, Charles was good-looking and charismatic. However, the obstacles he faced to reclaim the throne for the Stuart dynasty were enormous. He had to persuade the French to back an armed uprising on British soil and also gather supporters in a land he claimed as his own, but had never lived in. Against him were the disciplined, well-organised armies of King George II, able to draw upon the resources not only of Britain but also of his other kingdom of Hanover (in modern-day Germany).

Young Charles sailed from France with just a few supporters to the Scottish island of Eriskay in July 1745. It is said he burnt his ship to avoid the temptation of leaving before the uprising began, but he may have regretted his decision when the first local clan chiefs he met urged him to return to France.

But he refused to give up hope and continued to the mainland of Scotland. Many Scots in Highland areas were Catholic and supporters of the Stuart cause, so Charles hoped they would form the core of his rebel army. The risk he took began to pay off as Highland chiefs and their clansmen joined him, and soon Charles was leading an army south, intent on capturing the Scottish capital at Edinburgh.

The Jacobite army was fortunate to enter Edinburgh without having to fight. For the next six weeks, Charles held court in the traditional Stuart residence of Holyrood Palace, hosting balls and charming local worthies and their daughters. A handsome man of about five foot ten with dark red hair, he deserved his "Bonnie" nickname. It was during this short stay that the prince's men sent for Allan Ramsay (1713–84).

Then aged just over thirty, Ramsay was from Edinburgh but had travelled widely, studying painting in London and Italy. He was by all accounts a likable man, Samuel Johnson remarking, "You will not find a man in whose conversation there is more instruction, more information, and more elegance than in Ramsay's." His artistic skill took Scottish portraiture to a new level, and his charm no doubt helped increase his growing clientele of aristocrats and prominent members of society.

It is intriguing to think how Charles and Ramsay interacted with each other as the prince sat for the artist in Holyrood Palace. They were both up-and-coming men in their own fields, although it might seem odd that Charles—preparing to invade England—would find time to spend hours sitting for an artist. However, this was not just a vanity project for Charles, but also an exercise in royal propaganda at its purest.

For years, the Stuart family in exile in Europe had circulated portraits of Charles and his younger brother Henry to Jacobite sympathisers wherever they were found, and Ramsay's portrait was intended to show the prince in situ having reclaimed the old Stuart royal palace in Edinburgh. The portrait once finished would be copied and an engraving made for the purposes of coinage and any other official medium that needed an image of the prince.

When Ramsay was finished, it seems likely that Charles took the portrait with him when his Jacobite army left Edinburgh to begin its fateful invasion of England. Charles, ever the optimist, no doubt believed the portrait would soon be in London, helping propel his royal image around Britain.

But fate had other plans for Charles. For a few weeks, the Jacobites pushed their way far into England, making it as far as Derby, just 125 miles from London. It was here that everything fell apart for Charles as his council of advisers lost its nerve, believing George II's armies were now organising a counterattack that would destroy them.

Allan Ramsay self-portrait, c. 1737–39, Allan Ramsay (1713–1784), oil on canvas, 24 x 18.25 in. (61.0 x 46.4 cm), National Portrait Gallery, London

For once young Charles' powers of persuasion failed, and—bitterly—he was forced to lead his army north to escape destruction. Once the retreat began, the Hanoverian forces refused to give up their relentless pursuit. The tragic end came just a few months later and four hundred miles to the north of Derby at Culloden, the battle that saw the Jacobite army destroyed and Charles forced to flee for his life.

In the aftermath of Culloden, "Butcher" Cumberland's forces inflicted savage reprisals in Scotland, particularly amongst the Highland clans that had supplied most of Charles' troops. Thousands of suspected Jacobites were executed, jailed or deported to plantations in the British colonies.

Charles himself was lucky to survive, chased across Scotland, sleeping under the stars and at one point being disguised as a woman. He eventually managed to escape back to exile in France.

By contrast, the fortunes of Allan Ramsay were on the up. Despite having painted a portrait of George II's number-one enemy at Holyrood, Ramsay seamlessly navigated the choppy political waters of the age. He moved to London and painted many portraits of key figures in the Hanoverian royal family, including a magnificent portrait of a young George III in his coronation robes in 1761. All the while, Charles remained in Europe, drinking heavily. Having almost secured the British throne through his audacious efforts whilst in his mid-twenties, he achieved very little for the rest of his life, dying a broken man in Rome in 1788 aged sixty-seven.

Back in London, Ramsay's portraits of the royal family were produced in a manner resembling an assembly line, with a team of assistants making hundreds of copies of original paintings for distribution to loyal aristocrats, ambassadors, officials in overseas colonies, and George II's subjects in his other kingdom of Hanover.

Ramsay, the man who had drawn Bonnie Prince Charlie from life in Edinburgh, would become official painter to George III. When it was suggested the king sit for a promising new artist in London named Joshua Reynolds, George III responded, "Mr Ramsay is my painter, my Lord."

Ramsay's Edinburgh painting of Charles had its own incredible journey. Having disappeared after Culloden, it was presumed lost forever. However, for many years there was some compensation in the fact that the Scottish National Gallery in Edinburgh had another fine pastel portrait of Charles by Maurice Quentin de la Tour—or at least thought it had until 2009 when

art historian Dr. Bendor Grosvenor caused a major upset by proving this portrait was actually of Charles' younger brother Henry.

Up until Grosvenor's involvement, this false image of Charles had featured on everything from shortbread tins to book covers, and was for many people the definitive image of Bonnie Prince Charlie.

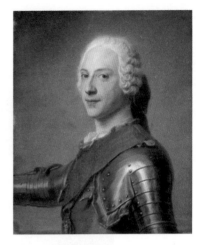

Prince Henry Benedict Clement Stuart, 1725–1807. Youngest son of Prince James Francis Edward Stuart, 1746–47, Maurice Quentin de la Tour (1704–81), pastel on paper, 24.0 x 20.1 in (61 x 51 cm), Scottish National Gallery, Edinburgh

Grosvenor redeemed himself in 2014 when his research discovered that Allan Ramsay's lost portrait of Charles was hidden away at Gosford House, the stately home of the Earl of Wemyss not far from Edinburgh.

A descendant of the current earl had bought the picture of Charles not long after the defeat of the Jacobites at Culloden.

The tiny picture, just 12 inches by 10 inches, is one of Ramsay's finest portraits and today hangs in the Scottish National Portrait Gallery, the mislabelled portrait of younger brother Henry having been removed from public view.

FLORA MACDONALD

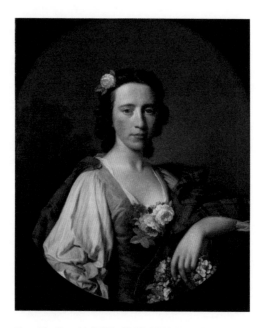

Flora MacDonald (1722–1790), 1749, Allan Ramsay
(1713–84), oil on canvas, 29.1 x 24 in (74 x 61 cm),
Ashmolean Museum, University of Oxford

After the Battle of Culloden, Bonnie Prince Charlie spent five months as a fugitive travelling back and forth in the Scottish Highlands and Islands. He was a wanted man, with a bounty of £30,000 on his head (around £16 million in today's money) placed there by the Hanoverian regime. But he was never betrayed, least of all by a brave Gaelic woman named Flora MacDonald from the isle of South Uist, who helped the prince escape capture by the British army. It was she who dressed him as a woman and named him Betty Burke.

Thanks to his brief encounter with Flora and others, Charles escaped to France. But Flora, who risked her life to save Charles, was not so fortunate. She was arrested and imprisoned for a period in the Tower of London.

A Jacobite sympathiser and friend of Allan Ramsay named Dr Richard Mead appears to have commissioned Ramsay to produce a portrait of Flora upon her release from prison, and it is one of the artist's finest works.

In her hair, she wears a white rose, symbol of the Jacobite cause; the other flowers in the portrait attest to her name. Ramsay must have trodden a fine line between his Jacobite friends and his Hanoverian patrons.

Flora MacDonald would later emigrate to America, where her husband fought with the British during the American War of Independence. She would eventually come home to Scotland, dying in 1790 on the Isle of Skye. ✦

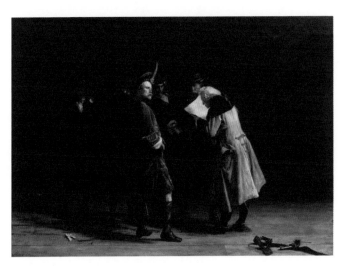

Jacobites, 1745; 1874, John Pettie (1839–1893), oil on canvas, 35.7 x 50.1 in (90.8 x 127.3 cm), Royal Academy of Arts

THE HOUSE OF STUART

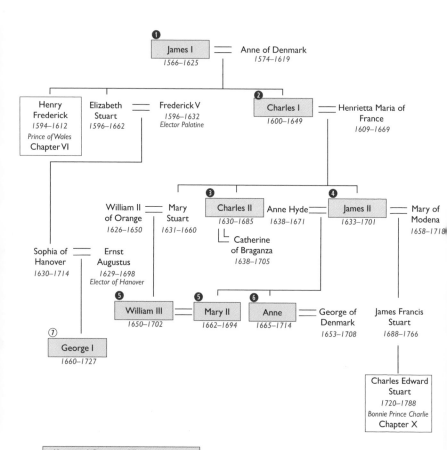

James I
1566–1625

Anne of Denmark
1574–1619

Henry Frederick
1594–1612
Prince of Wales
Chapter VI

Elizabeth Stuart
1596–1662

Frederick V
1596–1632
Elector Palatine

Charles I
1600–1649

Henrietta Maria of France
1609–1669

William II of Orange
1626–1650

Mary Stuart
1631–1660

Charles II
1630–1685

Anne Hyde
1638–1671

James II
1633–1701

Mary of Modena
1658–1718

Catherine of Braganza
1638–1705

Sophia of Hanover
1630–1714

Ernst Augustus
1629–1698
Elector of Hanover

William III
1650–1702

Mary II
1662–1694

Anne
1665–1714

George of Denmark
1653–1708

James Francis Stuart
1688–1766

George I
1660–1727

Charles Edward Stuart
1720–1788
Bonnie Prince Charlie
Chapter X

Kings and Queens of England

❶ James I (1603–1625): Chapter VI

❷ Charles I (1625–1649): Chapter VII

❸ Charles II (1661–1685): Chapter VIII

❹ James II (1685–1688): Chapter IX

❺ Mary II (1689–1694): Chapter IX

❺ William III (1689–1702): Chapter IX

❻ Anne (1702–1714)

⑦ George I (1714–1727, the House of Hanover)

GEORGE III: THE MONARCH UNHORSED

A noble equestrian statue falls to mob rule

Pulling Down the Statue of King George III
1848, Johannes Adam Simon Oertel (1823–1909), oil on canvas, 32 x 41.3
in (81.3 x 104.8 cm), Collection of the New-York Historical Society

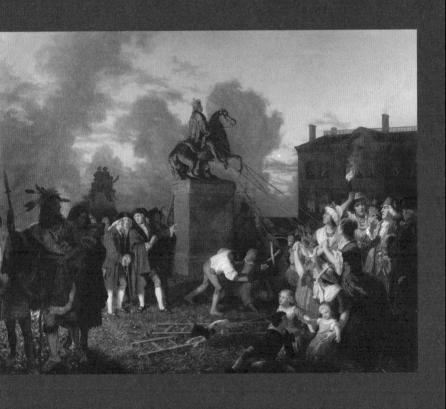

J uly 9, 1776, was a momentous day in the history of New York. Whilst Manhattan was under the control of the Revolutionary army under General George Washington, everyone knew the British army had landed on Staten Island and was closing in. Residents and troops were nervous and anxious about the future. The atmosphere was unstable—and dangerous.

At about 6 pm, Washington's troops assembled on New York's Commons (near to today's City Hall), joined by many civilians. They all listened as officers read out the Declaration of Independence, which Congress had adopted on July 4.

The Declaration contained the immortal phrase, "all men are created equal," and stated, "These united Colonies are, and of Right, ought to be Free and Independent States." Less well-remembered are twenty-seven individual complaints aimed at a single man. For example, "He has plundered our seas, ravaged our coasts, burnt our towns, and destroyed the lives of our people." "He"—the object of this cold anger—was King George III, the British monarch.

After the reading of the Declaration was finished, civilians and troops celebrated on the warm summer night. People drank and let off steam, whilst those loyal to the British—and there were many in Manhattan—hid behind their doors, worrying about being attacked.

When it was dark, an army captain named Oliver Brown led a group of around forty sailors and soldiers to an open space known as the Bowling Green in Lower Manhattan, a short walk from the Commons. Probably joined by members of the Sons of Liberty and other citizens, Brown's mob—excited and full of adrenaline—was determined to exact revenge on the body of the king himself. George was thousands of miles away in England; however, their target was the next best thing: a beautiful, gilded equestrian statue of the king that stood in Bowling Green.

Brown's mob tied ropes around the statue to pull it down, but on the first attempt the ropes broke. The second attempt was successful, and the crowd cheered and screamed as the heavy statue crashed to the ground.

Nor was this an isolated case of vandalism. All over Manhattan symbols of the British were destroyed that hot night, including the royal coat of arms that adorned many churches. But it was the destruction of the king's statue that really fired the imagination of the revolutionaries in Manhattan.

Brown's mission appalled one man, however. The next day, Washington issued a stern statement that read, "Though the General doubts not the persons who pulled down and mutilated the statue in the Broadway last night were actuated by zeal in the public cause, yet it has so much the appearance of a riot and want of order in the

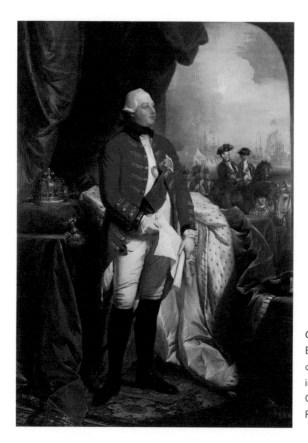

George III (1738–1820), 1779,
Benjamin West (1738–1820),
oil on canvas, 100.5 x 72.0
in (255.3 x 182.9 cm), East
Gallery, Buckingham Palace,
Royal Collection

army, that he disapproves the manner, and directs that in future these things shall be avoided by the soldiery."

Just ten years before, in 1766, the New York General Assembly had commissioned the doomed statue of the king in appreciation of the monarch's efforts to repeal the hated Stamp Act (which taxed documents in the North American Colonies). At this time, ironically, many Colonists regarded George as being on their side, acting as a buffer between them and aggressive British politicians.

A prominent English sculptor named Joseph Wilton was commissioned to create the statue. He constructed it out of lead and gilded the surface. Wilton modelled his design on the famous equestrian statue of Emperor Marcus Aurelius in Rome. Aurelius remains a legendary figure, as famous for his wisdom and skills as a philosopher as he is for his military pedigree. With the benefit of hindsight, comparing King George III to this illustrious emperor in such an ostentatious fashion was perhaps asking for trouble.

In 1770, the finished statue was shipped from England to New York, where, with much fanfare, it was unveiled in front of the great and good of the city. However, in the years that followed, George fell out of favour with many Colonists, who regarded him as having gone over to the side of those oppressing the thirteen Colonies. Graffiti began to appear on the statue. On the night when it was pulled down, Brown and his men must have wondered how long they had left in Manhattan, and no doubt regarded this as possibly their last chance to destroy a hated symbol of British power before the king's own army arrived to reclaim the city.

But the revolutionaries had another motive for their vandalism. The statue contained around two tonnes of lead that could be made into munitions. After it was toppled, large sections were transported to a foundry in Connecticut, where they were melted down to make over 40,000 musket balls. Ebenezer Hazard, New York postmaster, wrote a few days after July 9, "[George III's] statue here has been pulled down to make musket ball of, so that his troops will probably have melted Majesty fired at them."

Other parts of the statue survived. It is said that the head of George III was mutilated, and was due to be placed on a spike at Fort Washington. However, British loyalists managed to steal it back, and it was buried until the British reoccupied Manhattan a few months later and recovered it. It was then shipped to England, where it came into the possession of Lord and Lady Townshend.

Lord Townshend was a general in the British army and related to the politician responsible for the controversial Townshend Acts that imposed duties on goods imported to the American Colonies and so fanned the flames of the Revolution. A visitor to the general at his London home in 1777 recorded in his diary that he was asked, "if I had a mind to see an instance of American loyalty?" The visitor was then shown the head of the statue, noting "the nose is wounded and defaced, but the gilding remains fair … it was well executed, it retains a striking likeness." No one knows what happened to the head after 1777, but there is a chance it remains in a private collection today. Over the years, various pieces of the statue have turned up in fields and swamps in America. The New-York Historical Society holds the tail of the horse and other fragments.

A painting by German-born artist Johannes Adam Simon Oertel (1823–1909) and dating from c. 1852, is the best-known depiction of the statue being pulled down. The work is curious because it contains the figures of a North American Indian, an African American, and a number of women and children. It seems unlikely that this is a faithful representation of who was in the crowd that night, and Oertel probably intended it to be

symbolic of the various groups which made up the new republic.

George III was only in his late-thirties when the statue in New York was pulled down, and his reign could have recovered. However, he was forced to confront some of the greatest challenges in British history—the impact of losing his American Colonies, the fallout from the French Revolution and the rise of Napoleon, and the upheavals caused by the Industrial Revolution.

Even the strongest monarch would have struggled against this tide of history, and George was neither physically nor mentally robust. He suffered bouts of what was then regarded as insanity and gradually became blind as well. Eventually his illness became so debilitating, the king was kept in confinement, suffering degrading treatments that appear barbaric by today's standards. Even worse, the son he despised took over as Prince Regent (later ruling as George IV). It was a tragic end for a monarch who had once promised so much.

In a final twist to this story, over 240 years after the statue of George III was pulled down in the Bowling Green, StudioEIS, a Brooklyn company, produced a full-size replica based on historical evidence. It is now on display in the Museum of the American Revolution in Philadelphia, witness to a small but symbolic moment in the creation of the republic.

BENJAMIN WEST

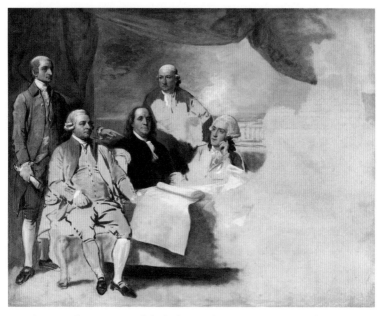

American Commissioners of the Preliminary Peace Negotiations with Great Britain, between 1783 and 1784, Benjamin West, unfinished oil sketch, 28.4 x 36.2 in (72.3 x 92 cm), Winterthur Museum, Garden and Library, Delaware

In 1779, not long after the equestrian statue of George III was pulled down in New York and the War of Independence was still in the balance, Benjamin West painted a portrait of the monarch that portrayed him as a masterful commander-in-chief, dressed in military uniform. His crown and ceremonial robes are—symbolically—laid to one side in order to emphasise his military role; his soldiers and navy ships are prominent in the background. The portrait was a propaganda piece, seeking to

bolster a reputation that the colonists in America had done so much to damage. Ironically, the artist who created it was an American and a friend of many of the revolutionaries who regarded George as a tyrant.

West's story is a remarkable one. Born in Springfield, Pennsylvania, in 1738, he became known in Colonial America for his historical paintings and was friends with Benjamin Franklin. In his early twenties, he arrived in England, never intending to stay long. However, his abilities as an artist ensured prominent commissions, and he decided to stay. Such was his popularity that he was known as the "American Raphael."

West came to the attention of George III and in the early 1770s was appointed a painter to the royal court. Thus he swiftly became part of the very British establishment his countrymen were seeking to destroy, culminating with his election as president of the prestigious Royal Academy of Arts in London.

As a court painter West sat with the king for many hours drawing from life, and must have talked to George about events in America. Did he bite his tongue as the king held forth on the colonists? Perhaps he even reported back to his old friend Benjamin Franklin what the British king was saying in private. Or did West support the British cause, realising where his future lay?

American Commissioners of the Preliminary Peace Negotiations with Great Britain, an unfinished painting begun by West in 1783, captured the sensitivity of the political situation at this time. The artist intended to portray the American and British delegations, which had arrived in Paris in 1783 to negotiate the treaty that would end the Revolutionary War. It is half-finished because the British delegation refused to sit for West, clearly unhappy about having their humiliation at the hand of the Americans immortalised in paint—by an American. ✦

GEORGE IV: LIBERTINE PRINCE, BIGAMIST KING

Two wives, two portraits

George IV (1762–1830)
1821, Sir Thomas Lawrence (1769–1830),
oil on canvas, 116.3 x 80.9 in (295.4 x 205.4 cm), Royal Collection

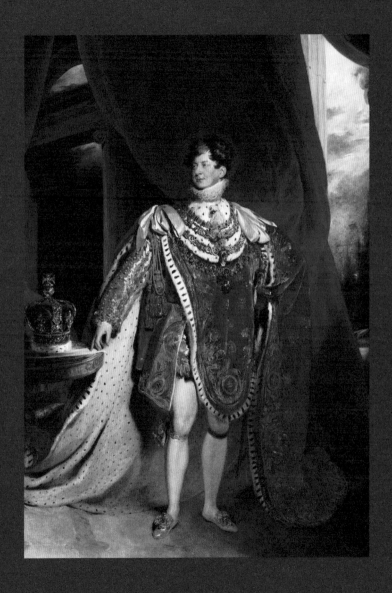

George Augustus Frederick (1762–1830)—eldest son of King George III, Prince of Wales, Regent and eventually King George IV—loved women. He had numerous affairs, leading a debauched lifestyle that made him notorious amongst his subjects. George even managed to be married to two women at the same time.

The first wife was a secret one, Mrs. Maria Fitzherbert (1756–1837). In a 1788 painting by Sir Joshua Reynolds, she is a bewigged and powdered beauty, demure (yet proud), fair of complexion and totally in control. Her eyes engage the artist and the spectator. The second wife was Princess Caroline of Brunswick, whose boisterous qualities, full figure and sweet face were captured by Sir Thomas Lawrence in a casual portrait set in the outdoors. The princess holds on to the brim of her bonnet with her right hand, as well she might for all the trouble her marriage would bring.

Mrs. Maria Fitzherbert was the love of George's life, although they were forced to marry secretly. Princess Caroline was the prince's official wife, but their marriage

was so dysfunctional that she was put on trial for adultery in the Houses of Parliament and left banging on the doors of Westminster Abbey in a vain attempt to gain admittance to her husband's coronation. Both women would play important parts in the story of the most outrageous, scandal-prone royal of the modern era.

Maria Fitzherbert was the first to come into George's orbit. Born into an upper-class Catholic family, she married a rich landowner aged just eighteen. When he died leaving her no money, she married again. However, when she was twenty-seven, her second husband died, as did their infant son.

Maria went into mourning, and—now financially independent—had no intention of finding another husband. However, one fateful night her well-meaning uncle persuaded her to end her social isolation by accompanying him to an opera. It was here that the Prince of Wales noticed her, asking her uncle, "Who the devil is that pretty girl you have on your arm?" From this encounter, the prince became infatuated with Maria. But it was hardly a match made in heaven. She was a respectable widow, several years older than the prince, and a strict Catholic. He was infamous for being a womanising gambler who rang up huge debts and drank and ate to excess. Universally unpopular with his own subjects, his behaviour was so outrageous that his father, George III, could hardly bear to speak to him.

To add to the prince's difficulties, under English law he could not get married without his father's permission, and if he married a Catholic he could not succeed George III as king.

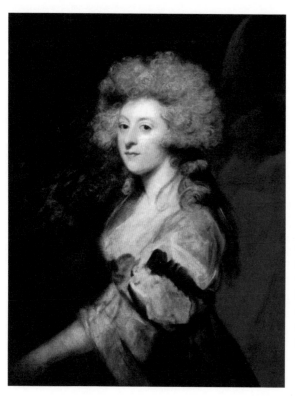

Maria Anne Fitzherbert (née Smythe, 1756–1837), c. 1788, Sir Joshua Reynolds (1723–92), oil on canvas, 36 x 28 in (91.4 x 71.1 cm), National Portrait Gallery, London

Despite these challenges, the prince continued to pursue Maria. She refused to become his mistress and pointed out the risks of any marriage. When she planned to move abroad to escape the pressures he was placing on her, the prince stabbed himself and threatened suicide.

Maria held out as long as she could, but eventually the prince's emotional blackmail wore her down. The couple were secretly married in December 1785 in a locked room in Maria's house in Park Street, Mayfair. The prince found a disgraced clergyman, the Rev. Robert Burt, to conduct the ceremony, every other man of the cloth being too worried about committing an act of

Caroline of Brunswick (1768–1821), 1798, Sir Thomas Lawrence (1769–1830), oil on canvas, 66.9 x 57.4 in (170 x 146 cm), Victoria & Albert Museum, London

treason as the marriage was technically illegal without the king's consent and breached statute. Even then Burt only agreed to marry the couple when the prince paid off the clergyman's debts, allowing him to be released from Fleet Prison.

Despite the need for secrecy and precautions taken, rumours began to circulate and satirical cartoons were published depicting the couple in unflattering terms, some suggesting the prince had married Maria in a Catholic church. The prince, concerned his succession to the throne would be blocked, mounted a vain attempt to fight the rumours, using his influence to have statements

Wife & no wife - or - a trip to the Continent, 1786, James Gillray, hand-coloured etching, 14 7/8 x 19 in (37.7 x 48.2 cm), National Portrait Gallery, London

made in Parliament denying the marriage. However, this only upset his new wife and ultimately convinced no one.

Maria moved to a house in Pall Mall, very near to the prince's own residence at Carlton House. Slowly, members of London society accepted her as the prince's de facto wife. The couple also lived together in Brighton, guarding their privacy so carefully that whilst they almost certainly had children together, no one is sure how many.

Maria was a tolerant woman, for years putting up with the prince's continued philandering, and even using her own modest fortune to pay off his gambling debts. Many people thought the prince was at his best when

he was with her, and it was during this happier period in their lives that Reynolds painted the 1788 portrait of Maria.

Born in Devon, Reynolds travelled extensively in Europe where he studied the Old Masters and developed his "Grand Style." In his thirties, he established himself as a portrait painter in London, quickly acquiring an influential, wealthy clientele that included many aristocrats.

By the 1760s, Reynolds was regularly commissioned by members of the royal family, painting portraits of George III and his wife, Queen Charlotte. His growing reputation helped change the way society viewed artists, and he served as the first president of the Royal Academy of Arts. Reynolds also received the rare honour for a painter in that era of being knighted by George III, and he became Principal Painter in Ordinary to the King. Although Reynolds probably did not realise it at the time, his portrait of Maria marked the end of his career. Despite being at the peak of his powers, the following year he lost the sight in one eye and was forced to retire from painting. Three years later he was dead.

Mrs Fitzherbert's life was also about to change for the worse just after Reynolds captured her. She had to suffer the humiliation of the prince effectively denying their marriage in order to squeeze more funds out of Parliament. By 1793, the prince's behaviour, including a relationship with Frances Villiers, Countess of Jersey, contributed to the unravelling of the marriage.

The end came when the king applied pressure on his son to marry a Protestant of royal birth in order to produce a legitimate heir and convince Parliament to

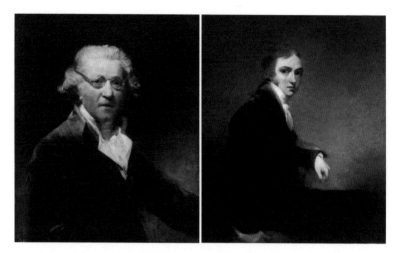

Left: *Sir Joshua Reynolds (1723–92), self-portrait,* c. 1788, oil on panel, 29.6 x 25.0 in (75.1 x 63.4 cm), Royal Collection

Right: *Sir Thomas Lawrence (1769–1830), self-portrait,* c. 1787–88, oil on canvas, 23.2 x 19.6 in (59 x 50 cm), Denver Art Museum

grant him money to clear his debts. And so, after nearly ten years of marriage, the prince ruthlessly informed Maria by letter that their relationship was over. A year later, in 1795, he would marry the Protestant Princess Caroline of Brunswick.

The marriage to Caroline was a disaster from the start. German-born Caroline had, it is said, a problem with personal hygiene, bad teeth and plain looks that the prince made clear from their very first meeting were not to his liking. On his way to the wedding, the prince told a companion, "It's no use, I shall never love any woman but Fitzherbert." Staggering drunk during the wedding

ceremony, the prince's shocking behaviour offended Caroline and their relationship never recovered.

Whilst Caroline bore George a daughter, Princess Charlotte, in 1796, the couple became estranged and began to live separate lives. George came to detest his lively and unpredictable wife, resenting her popularity with the public. For Caroline's part, she was determined to live her own life as far as she could and remained a thorn in the prince's side until her death.

Caroline's popularity amongst the common people was manifested everywhere she went, and even a trip to the opera would see the audience applaud her. Meanwhile, the prince would come skulking back to Maria Fitzherbert, but their relationship was never the same. In 1803, she finally left the royal court and retired from public life.

The portrait of Caroline by Sir Thomas Lawrence in 1798 dates from the early years of her separation from Prince George, and coincided with Lawrence's meteoric rise as the new star of the world of portraiture.

Like Reynolds, Lawrence was an outsider, born in Bristol and later moving to Bath. As a child, he was a prodigy, earning enough from his sketches to support his family (his father was a bankrupt innkeeper). In 1787, aged just seventeen, he arrived in London and was encouraged by the great Sir Joshua Reynolds himself.

Within a couple of years, Reynolds' illustrious career would be ended because of his eyesight, and the equally ambitious young Lawrence stepped into the gap left behind, one commentator describing him as "the Sir Joshua of futurity not far off." He would go on to succeed Reynolds as Principal Painter in Ordinary

to George III, and it was the king who commissioned Lawrence to produce a portrait of Caroline, his daughter-in-law. It was a commission that would nearly cost Lawrence his career.

When Lawrence stayed at Caroline's house in Blackheath in order to complete his painting, he unwittingly stepped into the minefield of a failed royal marriage. Rumours of Caroline's dissolute lifestyle were circulating widely, and the prince instigated a secret investigation into allegations that Caroline was taking lovers and even bearing them children. Lawrence became caught up in the mess and was forced to swear an affidavit that he had not become one of Caroline's lovers during his stay at her house.

Caroline, unable to secure custody of her daughter Charlotte and ostracised by the royal court, eventually moved abroad in 1814. Lawrence, accused of being Caroline's lover, nevertheless managed to repair his relations with the prince. This was no doubt for selfish reasons. Years of hard living had turned Prince George into a fat, oafish man, and he knew Lawrence was one of the few painters alive who could capture him in a way that masked the worst of these excesses.

George became Prince Regent in 1811 on account of the king's frequent bouts of insanity. Determined to divorce Caroline before she could become his queen, George funded efforts to gather evidence of his wife's adultery. Matters would come to a head in 1820 when George III died, and his successor was faced with the awful prospect of having a queen consort whom he detested.

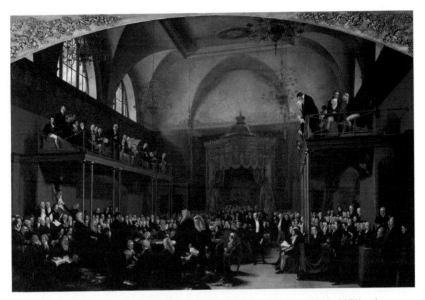

The Trial of Queen Caroline 1820, 1820–30, Sir George Hayter (1792–1871), oil on canvas, 91.8 x 140.3 in (233 x 356 cm), National Portrait Gallery, London

Caroline arrived back in London from exile on the Continent to assert her claim to be treated as queen. However, George used his political supporters to introduce a bill into Parliament that was intended to disqualify Caroline as queen on the grounds of her adultery. There followed one of the most controversial events in British political history as Caroline was in effect put on trial for adultery before members of Parliament. Witnesses were cross-examined on whether they had spied Caroline's lovers through a keyhole in her bedroom door or seen stains on her bedsheets.

The parliamentary bill failed, mainly because Caroline's defence team threatened to expose her

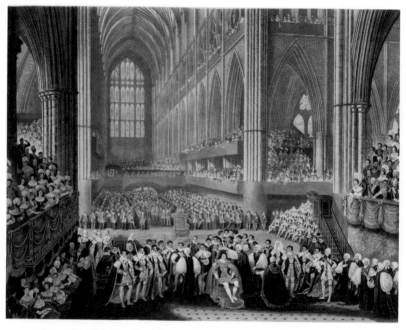

Coronation of George IV in Westminster Abbey. 19 July 1821, after James Stephanoff (1789–1874), etching with aquatint, hand colouring, Royal Collection

husband's own affairs and salacious behaviour. However, George was on the warpath and banned Caroline from his coronation in Westminster Abbey the following year. As stubborn as he was, Caroline refused to buckle under and turned up on the day, suffering public humiliation as the doors to the Abbey were shut in her face. Devastated, she died three weeks later aged just fifty-three.

The outpouring of grief when Caroline died has echoes in what happened in Britain when another estranged princess, Diana, died in tragic circumstances

in 1997. In both cases, the royal family had to weather a storm of negative public opinion that took some time to fade away. Caroline's body was transported back to Germany, where she was buried in Brunswick Cathedral.

By comparison, the final years of Maria Fitzherbert were peaceful ones. George IV would die in 1830, and she would survive another seven years, passing away in Brighton aged eighty. George never forgot her. As he was dying he was delighted to receive a letter from Maria, keeping it under his pillow. He also requested that a miniature portrait of his only great love be buried with him.

Perhaps the only winner in this story is Lawrence. He managed to carefully navigate the dangerous waters of the royal marriage, spending many hours painting both Caroline and George despite the fact they hated one another. His superb portrait of George IV in his impressive coronation robes is also a reminder of the reality of life over the centuries for many females who have become part of the British royal family and refused to obey its unwritten rules. Whilst George IV stood proudly in his robes in front of Lawrence, did he think back to that day at Westminster Abbey with Caroline outside desperately trying to get in? We will never know but it was without doubt one of the most disreputable moments in the history of the British royal family.

HERE'S TO YOU, MRS. ROBINSON

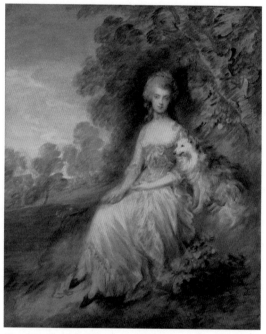

Mrs. Mary Robinson (Perdita, 1758–1800), c. 1781, Thomas
Gainsborough (1727–88), oil on canvas, 92 × 60.2 in
(233.7 × 153 cm), Wallace Collection

For his first mistress, George, Prince of Wales, and later George IV, could not have chosen a more extraordinary woman than Mrs. Mary Robinson (1758–1800), a published poet and actress. Her beauty—captured by Gainsborough—won her many admirers who flocked to see her on the stage. In December 1779, when she was twenty-one, she was performing as Perdita in Shakespeare's *The Winter's Tale*. In the audience one night was the Prince of Wales.

The prince was even younger than Mary, just seventeen, but he was instantly smitten. He wrote her love letters, addressed to Perdita and signed Florizel (another character in the play). Young and impetuous, he promised her money. But their affair, when known, did not win favour with the public.

Moreover, theirs was an uneven match-up, with Mary outstripping her lover in wit, intelligence and accomplishment. In addition to poetry, she wrote novels and plays. She also championed women's rights and supported the radicals of the French Revolution, leanings that did not exactly endear her to a vulnerable English monarchy. Nor did her independence of spirit bode well for a long-term love connection with the poorly mannered, spoilt teenage prince. Fickle and weak, he found another mistress.

But Mary was not about to go quietly. Heavily in debt, she wanted the money the prince had promised her. She threatened to go public with details of their affair. It was blackmail, and it worked. But when an illness paralysed her from the waist down, she was unable to act. Rejected by the prince, she retired from public life to concentrate on her writing. The poet Coleridge—a friend—described her as an "undoubted genius." But her poetry and novels, though popular and acclaimed, failed to bring in enough income to keep her in the style to which she was accustomed. Ill and embittered, she died in relative poverty.

Oddly, given the abrupt end of their relationship, the prince purchased Gainsborough's portrait of Mary in 1781, but would give it away years later. It is now in the Wallace Collection. He also purchased an oil sketch of Mary that Gainsborough had made in preparation for the painting. This study of the prince's mistress, bought after their relationship ended, is still in the Royal Collection. Obviously, the prince never forgot his teenage romance with one of the most extraordinary women of his era. ✦

PRINCESS LOUISE: VICTORIA'S ARTISTIC DAUGHTER

Royal by birth, scandalous by nature

Queen Victoria
1881, Princess Louise, Duchess of Argyll (1848–1939), pencil,
14.5 x 9.4 in (36.9 x 24.0 cm), Royal Collection

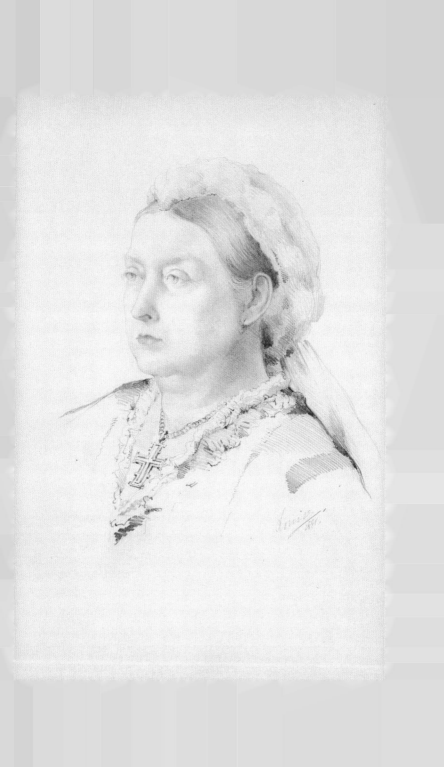

One day in the 1860s, so the story goes, an ambitious up-and-coming female sculptor was making love to an older, married man in an art studio. It was complicated because the man was not only one of the most famous sculptors in the country, but the young woman's teacher and mentor. Things got worse when they were rudely interrupted by the woman's mother, accompanied by her faithful servant. The mother, shocked at what she had stumbled across, was dressed in black, still mourning the death of her beloved husband. She screamed at her daughter.

And on this occasion, the young woman screamed back, one of the very few people who would dare stand up to such a formidable figure. The daughter accused her mother of hypocrisy, of having an affair with the kilted servant who stood by her side, and threatened to expose her mother's affair to the wider world if she continued to menace her.

The reputations of everyone in the studio were at stake because the young woman was Princess Louise, and

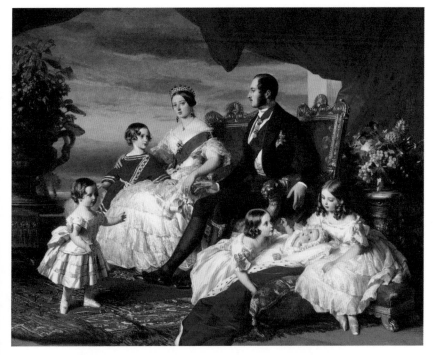

The Royal Family in 1846, Franz Xaver Winterhalter (1805–73), oil on canvas, 98.6 x 124.9 in (250.5 x 317.3 cm), East Gallery, Buckingham Palace, Royal Collection

she was shouting back at her mother, Queen Victoria. The married man in Louise's arms was the renowned sculptor Sir Joseph Edgar Boehm whilst the queen's servant—and rumoured secret husband—was John Brown, a lowly-born Highlander.

The scandalous scene has been reported in several biographies of Louise and other accounts. Even if it did not actually happen, it summed up the difficult relationship between Victoria and Louise, her rebellious

and bohemian daughter, who behaved like no other royal in history and lived an extraordinary life as an artist.

Louise, born in 1848, was the sixth of Victoria's nine children by her consort, Prince Albert. By today's standards Victoria was a difficult and often abusive parent. She bullied her children, micro-managed their lives, and inflicted emotional torments upon them all to such an extent that it would affect them negatively for the rest of their lives.

Louise was no exception. Whilst most male members of the royal family were expected to serve in the military or undertake official duties representing the monarchy, it was unheard of for princesses to attend ordinary educational establishments alongside commoners, or seek a professional life of their own.

But Princess Louise was drawn to the world of art—and the life of being an artist—from a very early age. It was her escape. In Britain the mid-19th century was certainly a time of change in the arts, particularly with the formation of the Pre-Raphaelite Brotherhood founded by influential figures such as John Everett Millais, Dante Gabriel Rossetti and William Holman Hunt, many of whom Princess Louise would become close friends with later in her life.

As Louise grew up, she quickly became regarded as the prettiest of Victoria's daughters, but her wilfulness began to grate on the queen who wrote of her as being "difficult" and "odd." She even wondered if the fact that Louise had been born in 1848—a year when revolutions swept through Europe—may have somehow influenced the behaviour of her own daughter.

However, the benefit of being a royal princess was evident when Louise received her first art lesson aged around four years old. This early experience would lay the foundations for Louise's desire to join the bohemian artistic community that was then flourishing in London.

She was able to persuade her mother to let her have her own studio within the royal residence of Osborne House on the Isle of Wight, and she herself would feature in many paintings of the royal family that were intended to show Victoria, Albert and their many children as the model family for their loyal subjects.

The reality for Victoria's children was very different. The queen continued to worry about Louise, writing when her daughter was sixteen that she had "so many difficulties to contend with. I hope and trust she will get over them all in time and still become a most useful member of the human family."

The death of Prince Albert in 1861 triggered a deep depression in Victoria, and she remained in mourning for the rest of her life. For many years she withdrew from public life, causing much resentment throughout the country. The pretty, sociable Princess Louise became for many the acceptable face of royalty, enormously popular and attending public events that drew enormous crowds and media coverage.

As a teenager Louise flourished under the guidance of a sculpting tutor, despite her mother's belief that it was not an interest that any lady should follow. In 1866, aged just eighteen, she completed her first sculpture on her own—probably one of the youngest female artists of her age in the country.

Sir Joseph Edgar Boehm (1834–1890)

It was around about this time that she might have conducted an affair with a member of the royal household. There has been much speculation that she had an illegitimate child with her brother Leopold's tutor, Lieutenant Walter George Stirling, and that the child was subsequently given up to the care of a family who had close ties to the royal family.

The secrecy around this scandal and a number of others involving the rebellious Louise may explain why historians have struggled to obtain information from the royal archives.

In 2004, Nick Locock went to the English courts for permission to obtain DNA evidence from the buried remains of his deceased grandfather Henry in an attempt to show Henry was Louise's illegitimate child with Sterling. The claim was that Henry had been adopted by Sir Charles Locock, a senior member of the royal household and an obstetrician who had been trusted enough to attend all of the queen's births and could clearly be expected to keep a scandalous royal secret. The courts turned down Nick Locock's request and the mystery of Louise's teenage years continues to this day.

When she was twenty, Louise finally persuaded Victoria to allow her to go to art school—the National

Art Training School. It was significant in many ways, not least because Louise would be the first member of the royal family to attend an "ordinary" public educational establishment.

Princess Louise, mid-1880s

It was around this time that Louise came under the influence of the prominent sculptor Joseph Edgar Boehm. They became lovers, despite the fact he was a commoner, already married, and fourteen years older than the princess. The affair would last for years.

Louise's life would continue to attract controversy as she developed as a sculptor and mixed freely with many of the leading artistic figures of her era, including Robert Browning, Oscar Wilde, Edwin Landseer, Arthur Sullivan (of Gilbert & Sullivan), George Eliot, James Abbott McNeill Whistler, Henry James, and politician and novelist Benjamin Disraeli. She was also closely involved with many members of what became known as the Aesthetic Movement, attending dinners, exhibition openings and social events with those who were described as celebrating art for art's sake. For

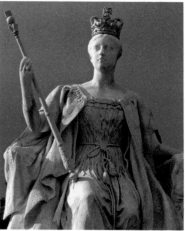

Left: Statue of Queen Victoria by Sir Joseph Edgar Boehm (1887–Windsor); right: Statue of Queen Victoria, Kensington Gardens, by her daughter Princess Louise

Louise it was a glorious period in her life, away from the stifling upbringing she had endured under Victoria's close control.

Seeking to further escape her controlling mother, in 1871 Louise agreed to marry a Scottish aristocrat named the Marquess of Lorne, later the 9th Duke of Argyll. Despite his aristocratic pedigree, some looked down upon him for being a commoner. But most of the British public loved Louise all the more for her choice, most of her siblings being married off to princes or princesses abroad in Germany and elsewhere in Europe.

However, it proved to be a difficult and childless marriage. By most accounts, Louise's husband was a homosexual during an age when homosexuality was a criminal activity. After marriage, she carried on her

affair with Boehm, and according to one story had the windows of a room in her matrimonial dwelling bricked up to prevent her husband getting out at night to meet young guardsmen in the gardens nearby. Victoria wrote of how her announcement of Louise's engagement was "the most popular act of my reign," which says a lot about how unpopular the queen had become during her period of mourning and rumoured dalliance with her servant John Brown.

Louise would live in Canada with her husband when he served as governor general of that country from 1878 to 1883, and the Province of Alberta is named in honour of one of her middle names. As a patroness of the arts, she lent her support to the Royal Society of Canada, the Royal Canadian Academy of Arts and the National Gallery of Canada. However, her heart was back in bohemian London, where she returned in 1881, two years ahead of her husband. There, she continued to sculpt.

Her most famous sculpture, perhaps oddly given the friction between her and her mother, is of Victoria. The marble work, unveiled in 1893, stands in Kensington Gardens in London and depicts Victoria in her coronation robes at the age of eighteen. Ironically, Louise's lover Boehm created a monumental bronze standing figure of a more mature queen, commissioned for the Golden Jubilee in 1887 and situated to this day at the foot of Castle Hill in Windsor.

Over the years, Princess Louise submitted paintings and statues to leading exhibitions in London and abroad, and whilst she was never judged to be in the upper rank of contemporary artists, her achievements

were considerable given much of her life was spent undertaking official engagements on behalf of her mother.

She also followed a very different course from her mother in supporting a number of causes linked to social reform and women's rights, including supporting the first female doctors and education for the poor. Victoria herself was passionately against any liberalisation of rights for her own sex, despite having full confidence in her own ability as a woman to reign over a world empire. The queen would on many occasions attempt to intervene when she saw Louise support too progressive a cause.

When her affair with Boehm came to a tragic end and he died in his studio in 1890, newspapers reported that Louise was visiting the studio and discovered his body. However, several historians have reported the alternative account that Boehm actually died whilst in bed with the princess, and her confidants quickly came up with a plausible story to explain why the queen's daughter was visiting the studio of a married man without any supervision.

Widowed in 1914, Princess Louise died at Kensington Palace in 1939. She was ninety-one.

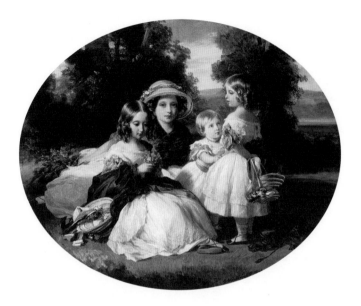

Victoria, Princess Royal, Princess Alice, Princess Helena, and Princess Louise
(second from right), 1849, Franz Xaver Winterhalter (1805–73), oil on
canvas, 22.2 x 27.5 in (56.5 x 69.8 cm), Royal Collection

QUEEN VICTORIA, ALBERT AND JOHN BROWN

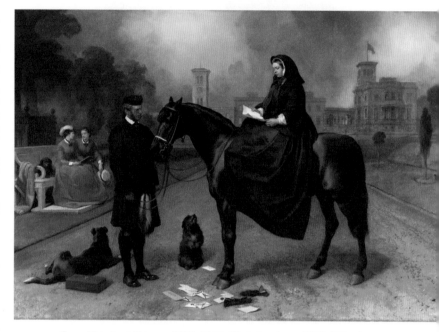

Queen Victoria at Osborne, 1865–67, Sir Edwin Landseer (1803–73), oil on canvas, 58.2 x 83.4 in (147.8 x 211.9 cm), Horn Room, Osborne House, Royal Collection

Did widowed Queen Victoria sleep with John Brown, her Highland servant? Were they secretly married? Such were the rumours that circulated after the death of her husband, Prince Albert, in 1861. The rumours persist to this day and have yet to be disproven.

Despite their frequent arguments, the marriage between Victoria and Albert was almost unique in the history of the royal family for being a monogamous one. Accustomed to having a man about the castle, Victoria in her widowhood naturally turned to Brown for

companionship. A no-nonsense, plain-speaking Scot, seven years the queen's junior, he treated her with affection and humour, and as an equal. They became inseparable.

Certainly the charming painting of the queen and Brown by Sir Edwin Landseer presents the public master/servant side of their relationship. The queen commissioned the portrait in 1865, with strict instructions that Landseer depict her "as I am now, sad & lonely, seated on my pony, led by Brown, with a representation of Osborne." What went on behind closed doors at Osborne, Buckingham Palace, Windsor Castle and Balmoral, however, remains a mystery.

Victoria is commonly described as highly sexed. She gave birth to nine children by Albert, even though her distaste of pregnancy is well documented. She was highly critical of her children. Seated in the background of the Landseer are two of those children: Princess Louise, the artistic

rebel, and Princess Helena. All of Victoria's children disliked Brown, viewing him as a usurper of affections and attention that should have been theirs. When Brown died in 1883, Victoria was once again plunged into deepest mourning, whilst her close family and courtiers were ecstatic to be rid of the common, brusque and controlling Brown.

In 1901 the Queen died after a reign of 63 years. Inside her coffin was placed a ring that had belonged to John Brown's mother and which he had given Victoria years before—perhaps evidence of the secret wedding Norman Macleod, church minister at Crathie Church near Balmoral, had apparently admitted to on his deathbed. She also asked for "a pocket handkerchief of my faithful Brown" and "a coloured profile photograph in a leather case of my faithful friend J. Brown." The photograph of Brown was placed in her left hand, with a bunch of flowers arranged artfully to ensure her family did not see it. ✦

AN ENGLISHMAN IN NEW YORK

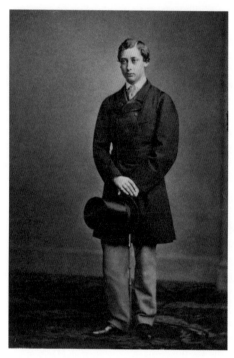

Edward, Prince of Wales, 1860, Mathew Brady Studio (1844–94), photograph, 3.4 x 2.3 in (8.8 x 5.8 cm), National Portrait Gallery, Smithsonian Institution

This photograph of eighteen-year-old Bertie, the Prince of Wales and eldest son of Queen Victoria, was taken in October 1860 in New York by one of America's pioneering photographers—Matthew Brady. The teenage Bertie standing in Brady's Broadway studio would have no idea that he would have to stand in his mother's shadow for forty-one long years before he finally succeeded her to the British throne. But here, on Broadway, he was the King of New York, feted everywhere he went.

Bertie's visit to America would be the first by a British royal since the crushing loss of the American Colonies less than eighty years before. The royal family was understandably worried about the reception

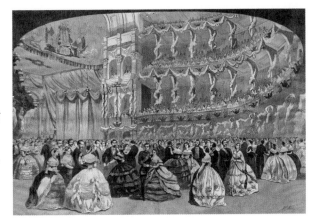

Grand Ball in honor of the visit of the Prince of Wales held at the New York Academy of Music on October 12, 1860

Bertie might receive from his American hosts. They need not have worried. Newspapers followed his every move, reporting on where he went, what he wore and what he ate; hundreds of thousands of people cheered him on. Suddenly, away from his ultraconservative parents, Bertie was the star of the show and he loved it.

Ever since Hans Holbein captured Henry VIII in the 1530s, the royal family had realised the importance of art in projecting an aura of power and majesty to the world at large. However, sitting for an artist required several hours, with further delays as paintings were finished,

then copied and engravings made to be distributed.

The fact that Bertie found time to visit a newspaper office on Broadway, and have his photograph taken by Brady on the same day, was significant. It showed the royal family was keenly aware of the possibilities of new forms of mass communication. Brady's photograph could be reproduced with relative ease compared to a painting, and also be used by newspapers whose circulations then ran into the millions. The propaganda power of Brady's new art form was obvious to the royals then—and now. ✦

ALEXANDRA AND ELIZABETH: SAINTLY ROYALS

From pleasures and palaces to immortality in heaven

The Marriage of Nicholas II, Tsar of Russia, 26th November 1894
1895–96, Laurits Regner Tuxen (1853–1927), oil on canvas, 66.7 x 55.1 in
(169.4 x 139.9 cm), The Queen's Gallery, Royal Collection

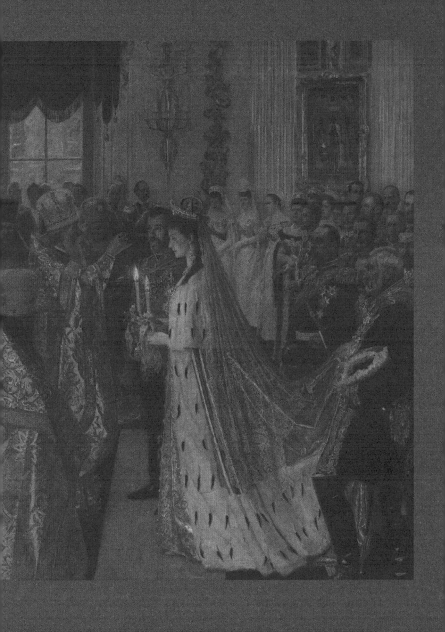

hroughout the ages, the British royal family has had and continues to have its fair share of sinners. But a bona fide saint among its ranks? That's a bit far-fetched. Or is it? Two sisters—granddaughters of Queen Victoria—have been canonised in the Russian Orthodox Church. The road to sainthood, however, was not an easy one for these martyrs to the Russian Revolution.

The more famous of the two sisters is Alexandra Feodorovna, wife of Tsar Nicholas II of Russia. Born in 1894 in Darmstadt, a city in the Grand Duchy of Hesse, Princess Alix, the future tsarina, was the daughter of the Grand Duke of Hesse and Princess Alice, the second daughter of Queen Victoria.

From the beginning, Alix's life was cursed. She was only six when her mother died of diphtheria. In the difficult years that followed, she would spend many holidays with Victoria and was one of the sovereign's favourite grandchildren. The queen, who relished her role as dynastic matchmaker, applied considerable pressure on Alix to marry another grandchild—Prince Albert Victor,

Duke of Clarence and Avondale. As the eldest child of
the Prince of Wales (later Edward VII), Eddy, as he was
called, was in direct line of succession to the throne. Alix
could have been queen, but she refused to do as Victoria
wished.

It was perhaps the greatest mistake of Alix's life.
If she had married Eddy, he may not have died of
influenza aged twenty-eight in 1892, and she would not
have married Nicholas in 1894. At her wedding in the
Winter Palace in St. Petersburg, Alix, now Alexandra,
wore a necklace and earrings that had once been owned
by Catherine the Great. However, for many people, the
wedding, held whilst the court was in mourning for
Nicholas' father, Alexander III, was a bad omen. The fact
that Alexandra's mother, Alice, had married during the
mourning period for her own father—Victoria's beloved
Prince Albert—suggested bad luck ran through this
branch of Queen Victoria's family.

Like her mother, Alexandra was never popular with
the people of her adopted country. The Romanovs were
regarded as autocratic, insensitive rulers, out of touch
with the difficulties faced by ordinary Russians. As radical
groups began to gain ground in Russia, many resented
the influence the monk Rasputin had over Alexandra,
making her even more unpopular. She also had to deal
with her son Alexei's haemophilia, a condition inherited
through Queen Victoria's bloodline.

When World War I erupted, Alexandra's German
heritage made the Russian people dislike her even more.
The February Revolution of 1917 saw a provisional
government formed, and Nicholas was forced to abdicate.
The provisional government wanted to send the family

Queen Victoria, at Balmoral Castle in Scotland, with her son Albert Edward, Prince of Wales (right), and Tsar Nicholas II of Russia (left). Seated on the left is Alexandra, Tsarina of Russia, holding her baby daughter Grand Duchess Olga. September 29, 1896

out of Russia, but tragically for the Romanovs no one wanted to receive them, including King George V of Great Britain, Nicholas' first cousin. When the Bolsheviks replaced the provisional government, the fate of the Romanovs was sealed. Lenin, head of the new Soviet government, had no intention of letting them leave the country.

On the fateful evening of July 16, 1918, after more than a year of house arrest, Nicholas and Alexandra played bezique whilst their five children—Olga, Tatiana, Maria, Anastasia and Alexei—went to bed. They had no idea that Lenin had given orders that the family should be killed that night. The Bolsheviks, worried that a White army was approaching, were not about to

allow the Romanovs to fall into its hands and become figureheads of the counterrevolution.

What happened next was grotesque. Nicholas, Alexandra and their children were woken up in the early hours of July 17 and taken to the basement of the house in which they were imprisoned in Yekaterinburg in the Urals. They were told they were going to be moved by lorry to a new location, but then soldiers entered the room and ordered them to stand. Nicholas was informed that they were to be killed.

Suddenly the men began to shoot, filling the basement with smoke. Nicholas was lucky to be killed almost immediately. Alexandra tried to bless herself before being shot and stabbed. Jewels hidden in the children's clothes prolonged their agony by stopping many of the bullets before the men moved in with bayonets to finish them off. Alexandra, the grandchild of Queen Victoria, would die curled up in a grim basement amidst the slaughter of her husband and children. The bodies were later thrown down a mineshaft and covered in acid, followed by grenades.

Further tragedy would follow the next day when Bolsheviks murdered Alexandra's sister Elizabeth at another location. Elizabeth had also married into the Russian imperial family. After a revolutionary assassinated her husband in 1905, Grand Duchess Elizabeth became a nun and founded a convent. Her death was even more barbaric than Alexandra's. She was beaten and then thrown alive into a deep pit. Grenades were thrown down and a fire started when moaning could still be heard. In 1984, the Russian Orthodox Church Abroad acknowledged her as a saint.

Years later, the remains of Nicholas, Alexandra and their children were found. A DNA sample from the Duke of Edinburgh, husband of Queen Elizabeth II and a grandnephew of Alexandra, confirmed the identity of the bodies. The remains were then buried with great ceremony in a chapel inside the Peter and Paul Cathedral in St. Petersburg. In 2000, Alexandra, like her sister Elizabeth before her, was canonised by the Russian Orthodox Church. They are the only lineal descendants of Victoria to receive such an honour—so far.

Tsar Nicholas II and his family: (left to right) Maria, Tsarina Alexandra, Czar Nicholas II, Anastasia, Alexei (front), and standing (left to right), Olga and Tatiana. c. 1914

CHAPTER XV

GEORGE VI: FAMILY MAN

Sir James Gunn paints the royals at their ease

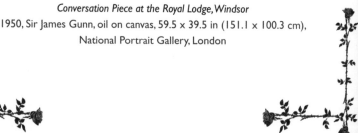

Conversation Piece at the Royal Lodge, Windsor
1950, Sir James Gunn, oil on canvas, 59.5 × 39.5 in (151.1 × 100.3 cm),
National Portrait Gallery, London

o modern eyes, the painting of the royal family by Sir James Gunn looks rather stiff, as if the subjects are trying—but failing—to look relaxed. King George VI sits with his legs crossed, a cigarette in his left hand, whilst one of the family's corgis lies dutifully behind him. The king's wife, Queen Elizabeth, pours tea, although one suspects servants normally did this for her. Their daughters, the princesses Elizabeth (sitting) and Margaret (standing), look at their father intently, so similar they could be twins.

Dating from 1950, Gunn's *Conversation Piece at the Royal Lodge, Windsor* nevertheless is poignant as it captures this close-knit family at a key moment in their personal history. The abdication crisis of 1936 and World War II were behind them; peace and stability, as symbolised by the ordinary act of taking afternoon tea, were theirs. But their lives were about to change once again in dramatic fashion. An alternative title for the portrait could be *The Calm Before the Storm*.

The king's cigarette tells the story. In 1950, he was just fifty-four, but unbeknown to him he was dying. As

a young man, he had been a gifted sportsman, playing tennis at Wimbledon and walking long distances whilst hunting deer, but his weakness was nicotine. He began to experience smoking-related circulation problems in his legs in the late 1940s, and in 1949 underwent major surgery in Buckingham Palace. The year after Gunn's painting, the king would be diagnosed with lung cancer, and his left lung was removed. The grim diagnosis was initially kept from him, but not long after Gunn's quiet domestic scene all four members of the family would realise the king was dying. Once again, fate forced this family of four to take on responsibilities they had never wished for.

In 1954, Sir James Gunn painted a portrait of the person responsible for the first upheaval: Edward, Duke of Windsor, who had succeeded his father, George V, to the throne upon the latter's death in 1936. However, as Edward VIII, he refused to give up his relationship with the twice-divorced American Wallis Simpson and abdicated the same year. As a result, younger brother Bertie (formally Albert) was forced to replace him as king, taking the name George VI. It was a role neither Bertie nor his wife was either prepared for or wished to take on.

Whilst Edward (known to his family as David, one of his seven names) lived the life of a playboy as Prince of Wales and heir to the throne, Bertie settled down. He met Lady Elizabeth Bowes-Lyon, daughter of the Earl of Strathmore and Kinghorne, at the start of the 1920s. The courtship was not an easy one as she already had a very privileged life and feared the loss of privacy that was inevitable when anyone joined the royal family. Bertie

proposed three times before she agreed to marry him, but it was worth it. They would be titled the Duke and Duchess of York, and Elizabeth would swiftly become a steadying influence on Bertie, helping her nervous husband cope with the many challenges that lay ahead.

One of these arose in 1925 when Bertie stammered his way through a speech at the British Empire Exhibition. The humiliation was so great that the Yorks sought the help of Lionel Logue, a speech and language therapist. Logue's treatment would greatly increase Bertie's confidence in public situations, although his dread of giving speeches would never leave him. The interaction between the two was immortalised in the 2010 Oscar-winning film, *The King's Speech*.

Bertie and Elizabeth decided to have as normal a family life as possible. Their first daughter, Elizabeth, was born in 1926; Margaret followed in 1930. The family was unusually close. Bertie, Elizabeth, Lilibet (their nickname for daughter Elizabeth) and Margaret would often play games together or dance after dinner, and take part in activities such as horse riding in Windsor Great Park.

In the 19th century, Queen Victoria commissioned several paintings of her large family, one aim being to show to her subjects that the monarchy was honest, respectable and "normal" like them. In reality, Victoria's family was deeply dysfunctional. Gunn's portrait of the four mid-20th-century royals had a similar purpose as propaganda, but at least it was more honest given the strong ties between the people depicted. If you did not know who they were, you might mistake them for just

another well-off English family gathering around the dining table for afternoon tea.

The location of the painting at The Royal Lodge in Windsor Great Park was, however, important. The Lodge was first occupied by George IV as a refuge away from public life, and a portrait of George looms large over the fireplace in Gunn's scene—ironically so, given the stark contrast between George IV's chaotic and unhappy home life and George VI's domesticity. King George V granted The Lodge to Bertie and Elizabeth in 1931 as a country retreat. This was where the family were probably at their happiest, away from the public gaze and the more rigid formality of other royal residences.

In the early 1930s, when the Yorks spent a great deal of time at The Lodge, they regularly saw Bertie's older brother Edward, and they all got on well. However, everything would change when Edward met the American divorcée Wallis Simpson. When Edward abdicated in 1936, the British public were shocked, and had to adjust to the fact that their king was not the dashing, popular Edward, but the shy, stammering Bertie.

For the Yorks, the change was also largely negative. Bertie, whose physical and mental health was fragile, would have to transform himself into a strong king who would inspire his subjects and win their hearts. Meanwhile the relationship between the two sisters would also change. Whilst Margaret was the younger of the two, she was more charismatic and was regarded as the star of the family. Now, with Lilibet next in line to the throne, she was just the "spare heir." As much as Bertie tried, this was no longer an ordinary family, and Margaret would grow to resent her reduced position in the pecking order.

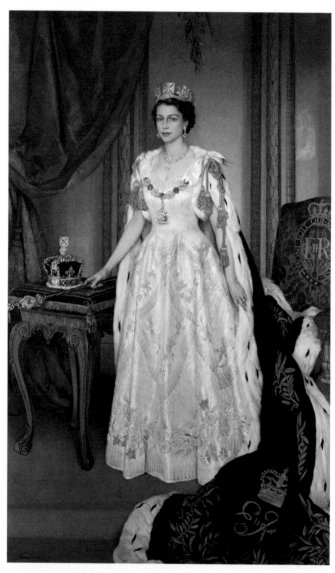

Queen Elizabeth II in Coronation Robes, 1953–54, Sir James Gunn (1893–1964), oil on canvas, 96.3 x 60.2 in (244.5 x 152.9 cm), Garter Throne Room, Windsor Castle, Royal Collection

Against everyone's expectations George VI developed into a good king, one who had perhaps the most difficult job of any monarch in modern history when the Germans threatened to invade Britain during World War II. His family earned the respect of the nation by refusing to seek refuge abroad, living in Buckingham Palace even after it was bombed. The family survived, and became hugely popular, defying those who wished Edward had stayed on the throne. But the huge burden on George VI began to exact a grim toll, and the family was soon to unravel.

If you look at Gunn's painting of the family again, you might be surprised to learn that the eldest daughter Elizabeth was already married with one child and another due the same year. She had married Prince Philip of Greece and Denmark in 1947, despite concerns within the family about his suitability. On the positive side, Philip was a good-looking, humorous man, whom Elizabeth had adored since her teenage years. The negative aspects were that he was arrogant, penniless and seen by many as a puppet of his hugely ambitious uncle, Lord Mountbatten. Philip's family also had unfortunate ties to Nazi Germany—hardly something to endear him to the British public after several years of a brutal war.

Bertie was cautious about Philip. It is therefore significant that Gunn's painting does not include his son-in-law (or indeed his grandchild, Prince Charles) and is restricted to the core family that had survived so much in previous years. Tellingly, just after Elizabeth married Philip, George VI had written to her saying, "I felt that I had lost something very precious … Our family, us four, the 'Royal Family,' must remain together with additions

of course at suitable moments!!! ... do remember that your old home is still yours & do come back to it ..." The phrase "us four" is significant as that is how the king saw his family—everyone else was secondary—although, again tellingly, the family's corgi made it into the painting. Gunn later said the most difficult thing about painting the family was controlling the dog.

In 1952, the king died, and Elizabeth succeeded him, decades before she would have if her father had lived to a normal age. Gunn painted a formal full-length state portrait of the queen in her coronation robes in 1953. Lilibet has gone, and the new queen looks a little as if she would rather be somewhere else.

Very soon after, she was forced to intervene in another royal scandal involving a married lover, this one involving Margaret and a dashing RAF hero named Peter Townsend, who was considerably older.

Townsend had been equerry to George VI and therefore knew Margaret. Regarded as the love of her life, he was nevertheless married with children. When Margaret made it clear to her sister, the queen, that she intended to marry Townsend as soon as she was able, a royal drama unfolded. Once again, the political establishment and the Church of England made it clear that they could not allow such a marriage to take place, unless Margaret were to give up all claims to the throne, her titles and income.

Queen Elizabeth II stood against Margaret, only escalating what one biographer described as a "Shakespearean case of sibling rivalry." In Gunn's painting of "us four" there is no discernible difference in the status or even the appearance of the sisters. However, in the

often ruthless world of the royal family, Elizabeth, as monarch, would be forced to make decisions about her own sister's personal happiness that no sister should ever have to make. Under intense pressure, Margaret and Townsend ended their relationship, and whilst they would each marry other people in the future, their lives were never the same and Margaret never forgave her sister.

Duke of Windsor, 1954, Sir James Gunn

The artist Sir James Gunn was brought up in Scotland and later saw action in World War I. After the war, he struggled to become a landscape painter and apparently only turned his hand to portraits through financial necessity. He would develop into a solid, respectable painter, increasingly favoured by politicians, civic leaders and members of the royal family.

Gunn also manged like many successful royal portrait painters, such as Sir Thomas Lawrence, to win commissions from people despite them knowing he also painted their bitterest enemies. In his portrait of the Duke of Windsor, dating from 1954, perhaps the duke's eyes betray a hint of guilt and embarrassment at the damage his own choices had made to "us four."

ELIZABETH II: THE SOVEREIGN AND THE BOHEMIAN

Her Majesty sits for Lucian Freud

Queen Elizabeth II
c. 1999–2001, Lucian Freud (1922–2011),
oil on canvas, 9 × 6 in (22 × 15 cm), Royal Collection

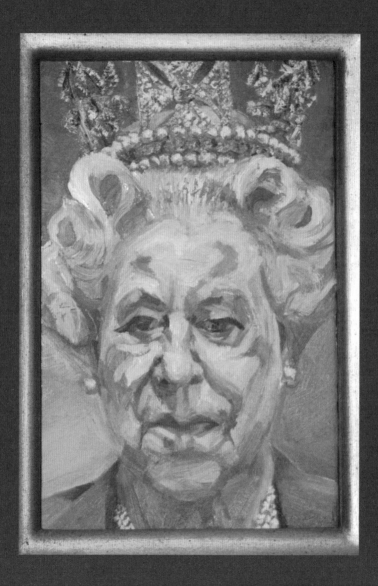

In the early 1930s, a nine-year-old German boy named Lucian was walking around his home city of Berlin with his governess when he saw Adolf Hitler surrounded by bodyguards. Lucian took out his camera and photographed the Nazi leader, later recalling how small Hitler seemed.

Seventy years later—in May 2000—Lucian Freud stood at an easel in a studio at St. James's Palace about to begin what would become one of the most controversial and unlikely pairings of an artist and subject in the history of the British royal family. In front of him sat Queen Elizabeth II.

Two men had a hand in leading up to this moment. One was Hitler. The Freud family was Jewish, and it was after one of Lucian's close relatives was killed by Nazis outside a café in Berlin that Lucian's parents became worried about their future in Germany and moved the family to England. Whilst Lucian had a difficult upbringing at times in England, often fighting with other boys as he struggled to learn English, it was almost certainly a decision that saved his life.

The other man responsible for Lucian painting a portrait of Elizabeth was the artist's grandfather—Sigmund Freud, father of psychoanalysis. Lucian was very close to his grandfather, who also immigrated to England in the 1930s to escape Nazi persecution.

With a world war looming, civil service bureaucracy held up the Freud family's application for naturalisation in the United Kingdom. However, Sigmund Freud persuaded a friend to use his influence with the Duke of Kent, younger brother of King George VI. The duke, in turn, ensured the paperwork was resolved quickly. When war broke out a few days later, the Freud family avoided the fate of many other newly arrived Germans who were sent as enemy aliens to internment camps in Britain.

Years later, Lucian Freud regarded his offer to paint the queen for no fee as a way of repaying the royal family for the Duke of Kent's intervention. This was a considerable gift as Freud's works fetched high prices; one painting, *Benefits Supervisor Resting*, sold at Christie's New York for over $56 million after the artist's death.

By the time Freud met Elizabeth for her first sitting, he had become legendary for not just his artistry, but also the extraordinary way he lived his life. He was a true bohemian, living almost entirely by his own set of rules in ways that very few artists have been able to do. He mixed with the aristocracy and hardened criminals. As a young man, he dated Greta Garbo, got drunk with Dylan Thomas and Francis Bacon, and became famous despite not giving a press interview for four decades. He regularly got into fistfights, even in his eighties. On many occasions the man regarded by many as Britain's

greatest living artist would turn up at friends' houses in the middle of the night to borrow money after gangsters (the Kray twins) had threatened to cut out his tongue or cut off his hand. His addiction to gambling and the huge debts he owed to bookmakers saw him banned from British racecourses for many years. His sex life was equally chaotic, and most accounts suggest he fathered at least fourteen children by several different women, although the figure could be nearer forty.

From the start, the combination of Freud and the queen was likely to be an unsatisfactory one. By the time she sat for him, Elizabeth had already had her portrait painted by over one hundred other artists. Many were good paintings, but compared with the advances in royal portraiture achieved in the past by figures such as Hans Holbein or Anthony Van Dyck, 20th-century representations of Elizabeth were generally uninspired.

Freud's paintings, on the other hand, were provocative and unflinching warts-and-all portraits of the human form, regarded by many as ugly and others as groundbreaking. The artist, who found worldwide attention for works such as *Naked Man with Rat* (1977), seemed to be the last person the queen would choose to paint her.

To pose for Freud was enormously demanding. Many of his paintings required the subject to sit or lie in uncomfortable positions on multiple occasions that often added up in aggregate to over 2,000 hours in the studio. Freud was an intense personality. His penetrating stare and habit of working during the night often exhausted his models.

This was one reason why he often asked unknown people to sit for him. Sons of bookmakers, young women he met drinking in Soho, acquaintances: Often they were so flattered to be asked, they would put up with the temper tantrums, long sessions and sometimes the demoralising climax when Freud destroyed the picture because he was not happy with the result. Freud liked to totally control the process of creating a picture, but the queen was not someone who was used to being controlled.

One issue was time. With over three hundred public engagements a year, Elizabeth was restricted in how often she could sit for Freud. The artist also had to rein in some of his instincts. Clearly the queen could not be asked to appear naked or lie at an odd angle on the floorboards.

Freud described the resulting process as being similar to mounting a polar exhibition, and sought to stamp his authority on the proceedings as far as he was able. He insisted on the sessions taking place in a studio in St. James's Palace, rather than the Yellow Drawing Room in Buckingham Palace where other artists customarily had worked with the queen in the past.

He also managed to persuade the queen to sit for fifteen separate sessions—far fewer than he was used to, but an astonishing testament to their stamina. Elizabeth was then aged seventy-three, Freud seventy-seven.

The diamond-and-pearl-encrusted diadem worn by the queen for the portrait—the George IV State Diadem, which she wore en route to her coronation on June 2, 1953—was hugely valuable, and initially security guards

stood inside the studio. Freud became frustrated with their presence and secured another minor victory when the queen sent the guards outside.

The painting itself was tiny—just nine and a half by six inches—a reflection of the limited time Freud had with the queen. Art historian Simon Abrahams has also pointed out the striking comparison between the painting of the queen and Freud's self-portraits. Freud himself admitted, "My work is purely autobiographical ... It is about myself and my surroundings. It is an attempt at a record." His painting of Elizabeth can be seen as really a portrayal of his alter ego, projecting himself onto the subject.

Whilst they were of a similar age, Freud and Elizabeth were very different people. Freud was an intensely private man, who refused to conform to social norms, often regardless of the hurt and damage he might cause. By contrast, Elizabeth had lived her whole life in the public eye, unable to make mistakes or disregard rigid royal protocols. Freud was Jewish; Elizabeth is the supreme head of the Church of England.

However, the two had more in common than might be generally known. Freud grew up with a deep love of horses and horse racing. At the progressive school he attended he even slept at night beside horses in a stable. The queen has a similar passion for horses and has bred many champion racers. During those fifteen sessions in St. James's Palace, they had at least one shared interest to talk about. Freud's friend Clarissa Eden later said, "Lucian had a whale of a time ... They talked about racing and horses. She kept on saying, 'We must stop talking. We must get on with this portrait.'"

Lucian's ties with the royal family went back many years before his portrait of Elizabeth. In the late-1940s and 1950s, he came into the orbit of Princess Margaret, Elizabeth's glamorous younger sister, whose "set" was one of the most exclusive of the era.

Freud would later recall living a decadent life in the 1950s in Soho, where his house regularly attracted shady acquaintances trying to avoid the police. On one occasion, he came under considerable pressure from the police after he acted as an alibi for a local car dealer suspected of murder. It was only after the newspapers reported that he had attended a social event with the queen and Princess Margaret that the police backed off, anxious about upsetting people in high places.

Another encounter between Freud and the royal family was less successful when Prince Charles, the queen's eldest son and a keen amateur watercolourist, suggested he and Freud swap paintings. Given that Freud's pictures sold for several million pounds apiece, he refused.

When Freud unveiled his portrait of Elizabeth, the reaction was polarised. The popular press was generally horrified at how the queen appeared, the Sun suggesting, "Freud should be locked in the Tower for this," and calling it a "travesty." The Telegraph described it as "extremely unflattering," whist the editor of the British Art Journal said, "It makes her look like one of the royal corgis who has suffered a stroke."

Other critics were more appreciative, calling it "thought-provoking and psychologically penetrating" and "the best royal portrait of any royal anywhere for at least 150 years."

The queen followed royal protocol and passed no public judgement on the portrait, which is now part of the Royal Collection. However, since she was fully familiar with Freud's work, there seems little doubt that she was entirely unsurprised at the bluntness and honesty of the portrait, or the general reaction to it. It is a credit to the queen that she was willing to take the risk, particularly when most monarchs—including many of her ancestors, as we have seen—seek only obviously flattering representations that reflect their position and power.

Over time, it seems likely that this collaboration between artist and sovereign will be regarded as one of the greatest portraits of a British monarch and certainly one of the bravest on the part of both Freud and Elizabeth herself.

THE TWO DIANAS

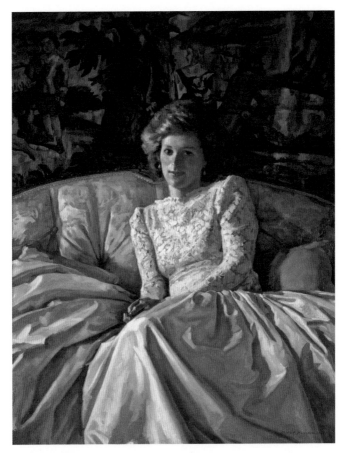

Diana, Princess of Wales (1986), Richard Foster, oil on canvas, Royal College of Physicians and Surgeons of Glasgow

Two women named Lady Diana Spencer came into the orbit of the royal family. One was the most famous, most photographed woman of the modern era; the other was a minor figure in British history. Neither was crowned queen.

In 1981, Lady Diana Spencer married Prince Charles, heir to the throne. In Richard Foster's portrait, for which she sat in the drawing room at Kensington Palace, Diana was in her mid-twenties, and whilst the British public was unaware of it at the time, her marriage to Charles was in trouble. The prince later admitted in an interview that it was in 1986—the year the portrait was completed—that he began to see Camilla Parker Bowles again, believing the relationship with Diana was effectively over in all but name. The couple's divorce was finalised on August 28, 1996; one year later, on August 31, Diana died in a car crash in Paris and was buried on the Spencer family estate of Althorp.

The first Lady Diana Spencer of Althorp, born in 1710 to Charles Spencer, 3rd Earl of Sunderland, and Anne Churchill of the powerful Churchill family, was orphaned at a young age and sent to live with her grandmother, Sarah Churchill, Duchess of Marlborough, arguably the most ambitious and powerful woman in British history who was not a royal.

Diana grew up to be a beautiful young woman and eligible potential bride. When she contracted scrofula, Sarah

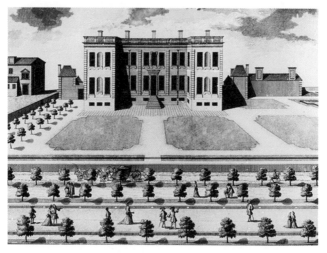

Marlborough House, Pall Mall, Westminster, London, c1720, John Harris I

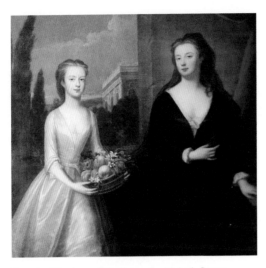

Portrait of Duchess of Marlborough with Lady Diana Spencer, c. 1722, Maria Verelst

employed a surgeon to cover up the telltale signs. Nothing would stand in the way of her plan to marry "Little Di" to Frederick, Prince of Wales, eldest son of George II.

Sarah knew Frederick was deeply in debt and offered him the enormous sum of £100,000 to marry Diana. Secret plans were made for the marriage to take place at The Royal Lodge in Windsor Great Park. However, Prime Minister Robert Walpole wanted Frederick to marry a European princess to help cement Britain's position on the Continent. Sarah was furious, although Lady Diana, ill with tuberculosis, probably regarded it as a lucky escape. She married Lord John Russell and became the Duchess of Bedford, but then in 1735—when she was only twenty-five and with no living children—she succumbed to tuberculosis.

Her brother John did have children, and one of his descendants was Viscount Althorp, who in 1961 named his daughter Diana, after his ancestor the Duchess of Bedford. She would, of course, grow up to become Diana, Princess of Wales. ✦

THE HOUSE OF HANOVER–WINDSOR

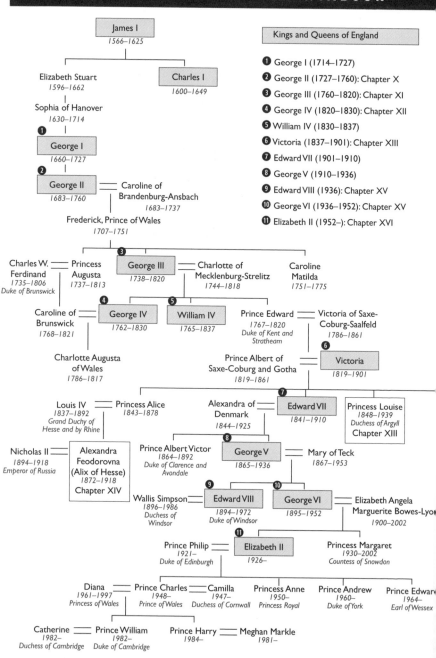

Kings and Queens of England

❶ George I (1714–1727)

❷ George II (1727–1760): Chapter X

❸ George III (1760–1820): Chapter XI

❹ George IV (1820–1830): Chapter XII

❺ William IV (1830–1837)

❻ Victoria (1837–1901): Chapter XIII

❼ Edward VII (1901–1910)

❽ George V (1910–1936)

❾ Edward VIII (1936): Chapter XV

❿ George VI (1936–1952): Chapter XV

⓫ Elizabeth II (1952–): Chapter XVI

James I
1566–1625

Elizabeth Stuart
1596–1662

Charles I
1600–1649

Sophia of Hanover
1630–1714

❶ George I
1660–1727

❷ George II — Caroline of
1683–1760 Brandenburg-Ansbach
 1683–1737

Frederick, Prince of Wales
1707–1751

Charles W. — Princess ❸ George III — Charlotte of Caroline
Ferdinand Augusta 1738–1820 Mecklenburg-Strelitz Matilda
1735–1806 1737–1813 1744–1818 1751–1775
Duke of Brunswick

Caroline of — ❹ George IV ❺ William IV Prince Edward — Victoria of Saxe-
Brunswick 1762–1830 1765–1837 1767–1820 Coburg-Saalfeld
1768–1821 Duke of Kent and 1786–1861
 Stratheam

Charlotte Augusta Prince Albert of ❻ Victoria
of Wales Saxe-Coburg and Gotha 1819–1901
1786–1817 1819–1861

Louis IV — Princess Alice Alexandra of — ❼ Edward VII Princess Louise
1837–1892 1843–1878 Denmark 1841–1910 1848–1939
Grand Duchy of 1844–1925 Duchess of Argyll
Hesse and by Rhine Chapter XIII

Nicholas II — Alexandra Prince Albert Victor ❽ George V — Mary of Teck
1894–1918 Feodorovna 1864–1892 1865–1936 1867–1953
Emperor of Russia (Alix of Hesse) Duke of Clarence and
 1872–1918 Avondale
 Chapter XIV

Wallis Simpson — ❾ Edward VIII ❿ George VI — Elizabeth Angela
1896–1986 1894–1972 1895–1952 Marguerite Bowes-Lyon
Duchess of Duke of Windsor 1900–2002
Windsor

Prince Philip — ⓫ Elizabeth II Princess Margaret
1921– 1926– 1930–2002
Duke of Edinburgh Countess of Snowdon

Diana — Prince Charles — Camilla Princess Anne Prince Andrew Prince Edward
1961–1997 1948– 1947– 1950– 1960– 1964–
Princess of Wales Prince of Wales Duchess of Cornwall Princess Royal Duke of York Earl of Wessex

Catherine — Prince William Prince Harry — Meghan Markle
1982– 1982– 1984– 1981–
Duchess of Cambridge Duke of Cambridge

TIMELINE

1066	Battle of Hastings; William the Conqueror crowned William I, the first Norman king of England
1078	Tower of London (White Tower) built
1097	Westminster Hall built
1189	Richard the Lionheart crowned Richard I
1337	Beginning of Hundred Years' War with France
1347	Siege of Calais by Edward III
1453	End of Hundred Years' War
1455	Beginning of the Wars of the Roses between the houses of York and Lancaster
1483	Death of Edward IV; Richard III crowned king after Edward V accedes to the throne for only two months (Chapter I)
1485	Death of Richard III during the Battle of Bosworth; Henry Tudor crowned Henry VII; end of the Wars of the Roses
1496	Henry VII issues letters patent to John Cabot and his sons to make a voyage of discovery (Chapter II)
1509	Death of Henry VII; son Henry succeeds him as Henry VIII and marries Catherine of Aragon
1534	Henry VIII forms the Church of England
1535	Hans Holbein the Younger appointed as Painter to Henry VIII (Chapter III)
1536	Execution of Anne Boleyn; Henry VIII marries Jane Seymour
1542	Scottish forces attack England at the Battle of Solway; death of James V of Scotland; infant daughter Mary becomes Queen of Scots
1547	Death of Henry VIII; Edward VI (age nine) succeeds him
1553	Death of Edward VI; Lady Jane Grey declared queen of England for nine days; Mary I crowned (Chapter IV)

1707	Union of England and Scotland as Great Britain
1714	Death of Queen Anne; accession of George I, elector of Hanover
1720	The South Sea Bubble financial crisis
1727	Death of George I; accession of George II
1746	George II defeats Bonnie Prince Charlie and the Jacobite army at the Battle of Culloden (Chapter X)
1760	Death of George II; accession of George III
1776	American colonies declare their independence from Britain (Chapter XI)
1801	Act of Union joins Great Britain (England and Scotland) and Ireland to create the United Kingdom of Great Britain and Ireland
1811	George, Prince of Wales, appointed Prince Regent
1820	Death of George III; accession of George IV; trial of Queen Caroline (Chapter XII)
1830	Death of George IV; brother William, Duke of Clarence, succeeds him as William IV
1837	Death of William IV; niece Alexandrina Victoria succeeds him as Queen Victoria (Chapter XIII)
1851	Great Exhibition
1894	Marriage of Princess Alix of Hesse, a granddaughter of Queen Victoria, to Nicholas II of Russia (Chapter XIV)
1901	Death of Queen Victoria; son Albert Edward succeeds her as Edward VII
1910	Death of Edward VII; son George succeeds him as George V
1914	Beginning of World War I
1917	King George V changes the name of the British royal family from the German Saxe-Coburg and Gotha to the English Windsor

ROYAL LONDON
WALKING TOURS

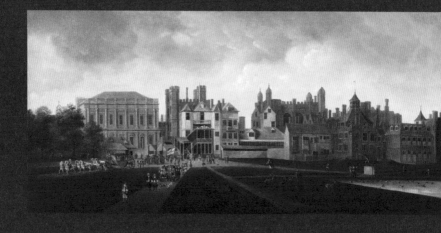

Above: *Whitehall from St. James's Park*, c. 1674–1675
Hendrick Danckerts (c. 1625–1680), oil on canvas, 41.3 × 88.6 in
(105 × 225cm), Department of the Environment

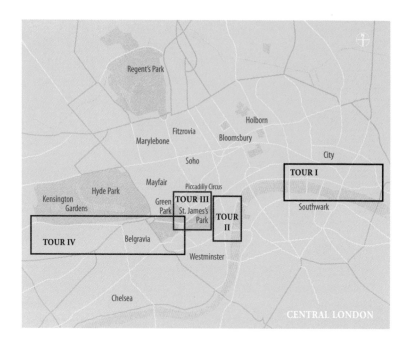

CENTRAL LONDON

For many centuries the royal family has not been content with one or two grand residences, but has occupied several palaces in London, each one associated with dramatic stories involving love affairs, executions, tragedies and political intrigues. One walk takes in two palaces—Kensington and Buckingham—both still used by the royal family. Another walk takes you through Whitehall where a vast royal palace once stood, sadly long since burnt to the ground, and where King Charles I had his head cut off shortly after walking under a ceiling painted by Rubens. A third walk, from Blackfriars to the Tower of London, takes you to where Henry VIII tried in vain to annul his marriage to Catherine of Aragon and where Lady Jane Grey was executed. And, finally, a walk around the exclusive district of St. James's passes another palace where Prince Charles lives and a street where Princess Margaret once dined.

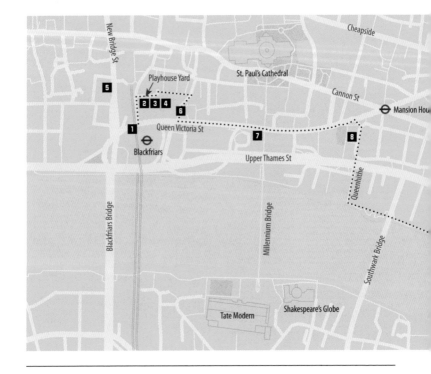

THE CITY—BLACKFRIARS TO THE TOWER OF LONDON

This walk takes you to the southern edge of the City of London—the original 'Square Mile' that formed the heart of the capital, and where the Romans built the first settlement called Londinium. It is here that Henry VIII tried to annul his marriage to Catherine of Aragon and Hans Holbein painted some of his finest paintings. The walk includes a visit to the Tower of London, which is worth taking at least a couple of hours to explore. It starts at Blackfriars Underground station and finishes at Tower Hill Underground station.

1. Exit Blackfriars Underground station, and follow the map up Queen Victoria Street and then up Black Friars Lane and then into Playhouse Yard.

2. Playhouse Yard is named for the Blackfriars Theatre that Shakespeare and his fellow actors used during the winter months as it had a roof. The more famous Globe Theatre, being open to the elements, was used when the

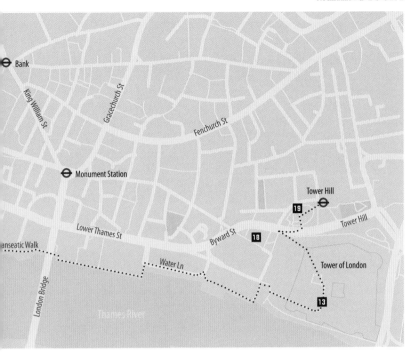

weather was better, and is located on the other side of the Thames. Shakespeare also owned a house near here.

3. This area is known as Blackfriars, the name derived from the black clothes worn by the Dominican friars whose priory stood here from the 13th century until 1538 when Henry VIII closed it during the Reformation. The priory was the location of one of the most dramatic trials in British history when Henry VIII sought to have his marriage to Catherine of Aragon annulled in 1529 (Chapter III). Henry despaired of Catherine giving birth to a male heir, so he argued that the queen's first marriage to his elder brother had meant her subsequent marriage to Henry was invalid under Catholic law. Catherine's spirited defence won the day, but it was only a temporary reprieve. Henry would soon force his nation to abandon the Catholic faith, and replace Catherine with Anne Boleyn as his queen.

4. Sir Anthony Van Dyck (1599–1641) was one of the very finest artists to be associated with the royal family, and his portraits of Charles I and his family made him the best-known painter in London (Chapter VII). He had a studio in Blackfriars, and Charles I had a jetty built here to allow him to visit Van Dyck by boat. In the days before the

construction of the Thames Embankment, the river came much farther in than today.

5. Not far from here to the west is the site of Bridewell Palace. Whilst not visited on this walk, this was a palace of Henry VIII, which later became part of a prison. It was also leased out in the 1530s to the French, and it is believed Hans Holbein painted his famous work *The Ambassadors* there in 1533. (Chapter III)

6. Walk along Ireland Yard and down St. Andrew's Hill. At the junction is the Cockspur pub, approximately where Shakespeare's house stood. You reach Queen Victoria Street again, turning left and continuing eastwards.

7. On the right you pass the City of London School, where Daniel Radcliffe, famous for playing Harry Potter, went to school. Opposite (north side) is the College of Arms, which for centuries has issued coats of arms to the great and good of the nation. Shakespeare applied for a family coat of arms from the college after making his money from the city's playhouses.

8. Shortly on the right walk down narrow Little Trinity Lane, where on the right is Painters' Hall. This is the home of the Worshipful Company of Painter-Stainers, one of many trade guilds formed in medieval London to protect the livelihoods of the city's tradesmen. Each guild had an apprentice system, and prevented competition in trade from anyone who was not a member.

9. The "Paynters" Guild was first recorded in 1283, and its members included artists who produced everything from portraits of aristocrats, bishops and royals to decorating barges

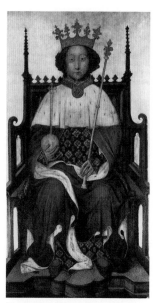

Richard II, 1394, Gilbert Prince

and churches. Gilbert Prince was a member, and it is believed that he is responsible for a painting of Richard II in 1394 that resides in Westminster Abbey and is the oldest surviving life portrait of a British royal.

10. For many years the Company kept a firm control over those who painted portraits of the royal family. In 1575, the Company even complained to Queen Elizabeth I that some of her portraits were being produced by artists, who had not served an apprenticeship with them. Hans Holbein, whose portrait of Henry VIII became so famous (Chapter III), was not a member of this Company as he was a foreigner. Many of these guilds still exist in London, although their aims are mostly charitable, and they no longer control professions in the way they once did.

11. Continue past the Hall to reach Upper Thames Street and cross over to reach Queenhithe and the Thames Path. Queenhithe is a rare surviving wharf of the type that peppered the edge of the Thames, and where boats could dock and be repaired and built. Continue eastwards, looking for the modern-day recreation of Shakespeare's Globe theatre on the other side of the Thames. After a few minutes you reach The Banker public house, and pass it to walk along Steelyard Passage, named for the Steelyard, which stood here in medieval times. This is near the former site of the Hanseatic League, a medieval trading organisation comprising merchants from what is today German and other northern European territories.

Steelyard

Hans Holbein produced mainly fine portraits of merchants of the Hanseatic League who lived and worked within their own walled community at the Steelyard in the 1530s. The League also commissioned Holbein to produce paintings for their Great Hall in the Steelyard— *The Triumph of Riches* and *The Triumph of Poverty*. Only copies now remain of these works as the originals were destroyed in a fire.

12. Now follow the Thames Path down by the riverside, heading east along the appropriately named Hanseatic Walk, with the Shard building dominating the view to the south. When London was the busiest port in the world, this part of London was crammed with wharves, with ships leaving and arriving from every known part of the world.

13. Continue along for several minutes, with one of the best views in London on one side. You pass along stretches of the walk named after trades and

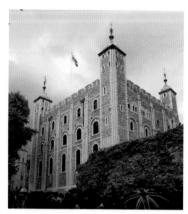

Tower of London

book (Chapter I) is the dark tale of Edward V and his younger brother Richard who were almost certainly killed here in 1483, after their uncle Richard plotted to take the throne as Richard III.

16. Tower Green, inside the walls, is where Lady Jane Grey was executed in 1554 (Chapter IV), as was Henry VIII's second wife, Anne Boleyn, in 1536. Both women, as well as Henry's fifth wife, Catherine Howard, were buried nearby in the Chapel of St. Peter ad Vincula, situated within the Tower. It is said the ghosts of Boleyn, Grey and the princes still haunt the Tower.

17. The trial of Anne Boleyn and her brother George took place in the King's Hall in the Tower in May 1536. Anne was accused of twenty acts of adultery with various men, as well as incest with George.

imported foodstuffs that used to dominate this part of London—for example, Oystergate Walk, Fishmonger's Hall Wharf, Sugar Quay Walk. At the end you reach the west side of the Tower of London (the ticket desks are on this side). This ancient site was founded by the Norman king, William the Conqueror, shortly after he defeated King Harold at the Battle of Hastings in 1066. It has too many connections with the royal family to be described in any detail during this walk but I would recommend that you visit the Tower and spend a few hours there.

14. Whilst for centuries it was a notorious prison, it was also (and remains) a royal palace, and many kings and queens lived here right up to the Tudor period.

15. A particular event associated with the Tower and detailed in this

Anne Boleyn

18. When finished at the Tower, and if you have any energy left, stop by the Church of All Hallows by the Tower. The diarist Samuel Pepys, referred to in the chapter on the Windsor Beauties (Chapter VIII), watched the Fire of London from the tower of the church in 1666. He lived very nearby. Charles II and his brother James (later James II) were active in trying to control the blaze, but their efforts were largely unsuccessful. More than 13,000 homes and nearly 90 churches were destroyed. The crypt contains a small museum which includes documents relating to parishioner William Penn, who was baptised here and would later found the American colony of Pennsylvania.

19. Cross over into Trinity Square and into Trinity Square Gardens. Whilst Lady Jane Grey and Anne Boleyn were executed in the relative privacy of the grounds within the Tower of London, many unfortunate prisoners had to suffer the indignity of a much more public end here. Thousands would gather to watch a notorious traitor being slaughtered.

20. A Martyrs Memorial marks the approximate site of the execution spot. People who died here with a royal connection include Catherine Howard (Henry VIII's fifth wife) and Jane Boleyn

Execution of the Duke of Northumberland on Tower Hill

(sister-in-law of Anne Boleyn). Jane had become tangled up in hiding Catherine's love affair with courtier Thomas Culpepper, with the result that Henry ordered both women to be executed in 1542.

21. Other notable figures connected to the royal family executed here include Sir Thomas More in 1535, George Boleyn in 1536, the Duke of Monmouth (Charles II's illegitimate son who led an uprising against James II) in 1685, and Lord Lovat (a supporter of Bonnie Prince Charlie) in 1747.

22. The walk ends here, and you are just a short distance from Tower Hill Underground station. ✦

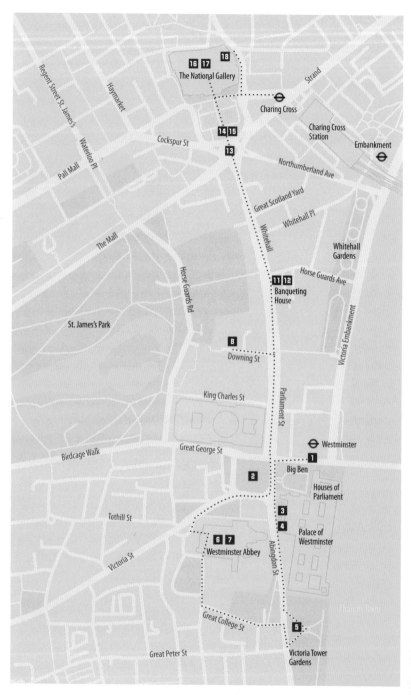

The National Gallery

16 **17** **18**

Strand

Charing Cross

Charing Cross
Station

Embankment

Cockspur St

14 **15**

13

Northumberland Ave

Great Scotland Yard

Whitehall Pl

Haymarket

Whitehall

Regent Street St. James's

Pall Mall

Waterloo Pl

Whitehall
Gardens

The Mall

Horse Guards Ave

11 **12**
Banqueting
House

Horse Guards Rd

Victoria Embankment

St. James's Park

8

Downing St

King Charles St

Parliament St

Westminster

Birdcage Walk

Great George St

1
Big Ben

2

Houses of
Parliament

Tothill St

3

4

Palace of
Westminster

6 **7**
Westminster Abbey

Abingdon St

Victoria St

Great College St

5

Great Peter St

Victoria Tower
Gardens

Thames River

WESTMINSTER TO TRAFALGAR SQUARE

This walk explores Westminster and Whitehall, today the political heartland of London but once the location of the royal family's Palace of Whitehall. This was the royal family's main London residence from 1530 to 1698, and many tragedies and triumphs took place during this period—including the public execution of Charles I. The walk includes a visit to Westminster Abbey, where over the centuries kings and queens have been crowned, married and buried. The walk finishes at Trafalgar Square and two great galleries which contain many works of art by artists mentioned in this book.

1. The walk begins at Westminster Underground station, where upon exiting you see the historic Houses of Parliament, the home of British democracy for many centuries.

2. Follow the map, keeping Parliament to your left. Opposite is Parliament Square Garden, which contains statues of many famous leaders, including Winston Churchill, Gandhi, Nelson Mandela and Abraham Lincoln.

3. On the left, you pass a statue of Oliver Cromwell, leader of the Parliamentarian forces during the English Civil War and the man chiefly responsible for ensuring the execution of the defeated King Charles I in 1649 (Chapter VII). Whilst Cromwell was the great hero of Parliamentary democrats in their battle against an absolutist monarch such as Charles, he is not universally admired, and his statue skulks in the shadows. Just a short way past Cromwell is a statue of Richard I, the famous "Lionheart," who led a glorious,

but ultimately doomed crusade to the Holy Land in the 12th century.

4. You can tour the Houses of Parliament on most Saturdays during the year, although you have to book tickets (there is a ticket office in front of Portcullis House on Victoria Embankment or you can book online: https://www.parliament. uk/visiting/). The tour includes historic Westminster Hall built in 1097. Many monarchs held their coronation feasts in the hall, including Richard I, Henry VIII, Elizabeth I and George IV. It was also the location of the trials of Sir Thomas More, William "Braveheart" Wallace and Charles I.

5. Continue past the Houses of Parliament and on the left is Victoria Tower Gardens. Near the middle is a cast of Auguste Rodin's *Burghers of Calais*, unveiled in 1915. The original in Calais, France, celebrates the heroism of the six citizens who

Rodin's *Burghers of Calais*

gave themselves to King Edward III after the English monarch was victorious in a near yearlong siege of the city that ended in 1347. Edward demanded that six citizens leave the city with nooses around their necks, barefoot and carrying the keys to Calais. However, his wife, Queen Philippa, persuaded Edward to spare them. Rodin's statue captures the burghers' despair as they walked towards the English, believing their lives were about to end. Ironically, Westminster Abbey, the final resting place of Edward III and his queen, is just a few hundred yards away from Rodin's monument.

6. From the Gardens cross over the road, looking out for a Henry Moore sculpture, to reach Great College Street. Walk down this street, and at the end turn right through a gateway to reach Dean's Yard by Westminster School. The towers of Westminster Abbey

are directly ahead, and cross the Yard to reach the Abbey itself. This is one of London's busiest tourist destinations so you might want to book tickets online to avoid queuing.(https://www.westminster-abbey.org) A visit is essential for anybody interested in the history of the royal family, not least because it is traditionally the place where monarchs are crowned, and where they and their families are buried. There have also been sixteen royal weddings in the Abbey.

Westminster Abbey, 1749, Canaletto

7. On July 19, 1821, Queen Caroline, the estranged wife of George IV, desperately tried to gain access to the Abbey during her husband's coronation (Chapter XII). Denied entry and humiliated in front of the public, her spirit was broken. She died a few weeks later, leading to an outpouring of public sympathy that had its modern counterpart in the period of mourning following the death of Princess Diana in 1997. Westminster

Abbey is normally open to visitors Monday to Saturday, and you can either buy entry tickets online or at the on-site ticket office. Verger-guided tours are available.

8. When finished at the Abbey, follow the map up Parliament Street. This is the heart of the British Government, housing the Foreign & Commonwealth Office, The Treasury and—most famously—the Prime Minister's residence at 10 Downing Street. However, all this was once the site of the vast Palace of Whitehall. The royal family originally occupied the Palace of Westminster (where Parliament stands) but Henry VIII—after getting rid of Cardinal Wolsey—re-located to the Cardinal's Palace of Whitehall in 1530.

9. The Palace of Whitehall would remain the principal London residence for the kings and queens of England until a terrible fire destroyed it in 1698. A sprawling, maze-like place with over 1,500 rooms, it was the largest of its kind in Europe.

Palace of Whitehall from the River Thames, c. 1647

10. Michelangelo's sculpture, *Sleeping Cupid*, was destroyed in the fire that devastated the palace—one of

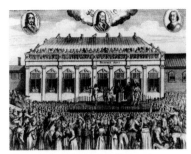

Execution of Charles I at Banqueting House, 1649

the great tragedies in art history. Hans Holbein's mural of *Henry VII, Elizabeth of York, Henry VIII and Jane Seymour* was also destroyed, although thankfully copies were made before the fire and these have gone on to be the defining image of Henry to this day (Chapter III).

11. On the right stop at Banqueting House. This is one of the most historically and architecturally important buildings in Britain. It is also the only substantive part of the Palace of Whitehall to survive the fire.

12. Designed by Inigo Jones in the neoclassical style (the first such building in the country), it was completed in 1622. A portrait of James I in the Royal Collection shows the house in the background. Charles I is the monarch most associated with Banqueting House as it was he who commissioned Peter Paul Rubens to paint the ceilings, an extraordinary feat by one of

history's greatest artists. Rubens painted the panels for the ceiling in Antwerp, and they were shipped over to London. They celebrate the Stuart dynasty, and James I, Charles' father, is shown at the centre. When Charles I was executed on January 30, 1649, he was led through Banqueting House and up to a scaffold by the first floor. The view of Rubens' magnificent ceilings, and his own father, would have been among the very last things Charles saw before he was led out of a window and onto the scaffold. You can visit Banqueting House every day of the week between 10 am and 5 pm, and tickets can be bought inside.

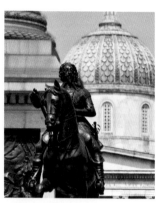

Charles I, 1633

I, which has an incredible story. It was cast in 1633, and should have been melted down for scrap during the Civil War. However, a metalsmith bought it and kept it hidden until Charles II returned to London. It has been here since 1675. The fact that Charles I stares down Whitehall to where he was executed is no coincidence.

14. Walk towards Nelson's Column, with the National Gallery behind it. The famous lions protecting the four corners of the column were the work of Edwin Landseer, the Victorian artist who is better known for his paintings. He gave Queen Victoria and Prince Albert drawing lessons and painted the picture of Victoria with her servant (and perhaps lover and husband) John Brown (Chapter XIII).

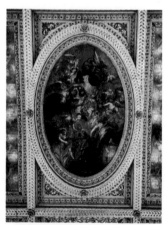

Peter Paul Rubens, Ceiling at the Banqueting House

13. After Banqueting House, continue up Whitehall to Trafalgar Square. En route, look out for the equestrian statue of Charles

15. It is said Landseer modelled the lions on the carcass of a lion, which had died at London Zoo

National Gallery

and was brought to his London studio. His studio stank as the dead lion began to rot, and Landseer hated the commission. The massive bronze lions were unveiled in the 1860s.

16. On the right as you walk towards The National Gallery is an equestrian statue of George IV, the controversial king and long-serving Prince Regent whose affairs, debauchery and lack of morals so appalled many members of Georgian society (Chapter XII).

17. Enter The National Gallery. Paintings normally on display are included in this book—Hans Holbein's *The Ambassadors* (Chapter III), among them.

18. If you have time you can visit the National Portrait Gallery next door. Here you can see many portraits of members of the British royal family. The walk ends in Trafalgar Square, near to Charing Cross train and Underground stations. ✦

The Ambassadors

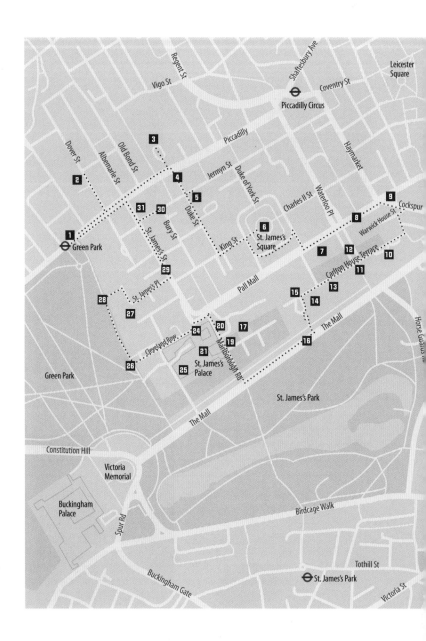

ST. JAMES'S PALACE AND SURROUNDING AREA

St. James's is a district of London that has long been favoured by the royal family since the 16th century, and Prince Charles lives here when staying in London. It is also the heartland of the British aristocracy and upper classes, who frequent exclusive members-only clubs that opened here centuries ago. Unsurprisingly, the area has also drawn to it upmarket shops, restaurants and art galleries that cater to the capital's wealthiest inhabitants. This walk begins at Green Park Underground station.

1. Walk up Piccadilly, stopping at Dover Street on the left. At 1 Dover Street is Mahiki, an exclusive nightspot. In recent years, this was a favourite spot for the young royals—Prince William and Prince Harry, in particular.

2. On the left at 40 Dover Street is the Arts Club, founded in 1863. Anyone who has watched *The Crown* will know that Prince Philip, husband of Queen Elizabeth II, liked to have a great deal of fun in his younger years, and this was one of his favourite haunts. Artists associated with the Arts Club include Frederic Leighton, Walter Sickert, Auguste Rodin, James McNeill Whistler and John Everett Millais.

3. Continue along Piccadilly to the Royal Academy of Arts in Burlington House. The courtyard has a statue of Sir Joshua Reynolds, the great English artist of the 18th century and the first president of the Royal Academy. Reynolds painted many portraits of members of the royal family, including George III in 1779. The Academy's collection contains works by artists from Reynolds to Tracey Emin.

4. From here cross Piccadilly and walk down Duke Street. The district of St. James's is one of the most exclusive in London, and home to many shops and upmarket clubs that have served royals, aristocrats and wealthy people for hundreds of years.

5. At the junction with Jermyn Street is The Cavendish Hotel. A hotel has operated here since the early 19th century, and it

Royal Academy of Arts

Rosa Lewis and Edward VII

became The Cavendish in 1836. King Edward VII is said to have entertained many of his mistresses at the hotel, and had an affair in the 1890s with Rosa Lewis, known as the "Queen of Cooks," who ran The Cavendish for several decades. Her life even inspired a BBC TV television series titled *The Duchess of Duke Street.*

6. Continue down Duke Street, passing many private art galleries and Christie's auction house. Turn left at King Street to reach St. James's Square. In the centre of the square's garden is a rare statue of King William III, known to many as King Billy. He was the husband of Mary II, daughter of James II, and came from the Netherlands with her to jointly rule after James II was deposed on account of his Catholic faith in 1688. William defeated James at the Battle of the Boyne in 1690 in Ireland, an event that features in Chapter IX. The equestrian statue shows William about to trip over a molehill—a real life event that led to him falling and his death a few weeks later. Afterwards his Jacobite opponents would often make a

toast to the mole at the end of their get-togethers.

7. Exit on the southeast side of the square onto Pall Mall. Three of the most famous and exclusive clubs in London are situated on the other side of the street: The Reform Club, The Travellers Club and The Athenaeum.

8. Head left (eastwards) up Pall Mall, named after a popular ball game— similar to croquet—introduced to England by James I in the early 17th century and which the royals used to play nearby.

9. Farther along is an equestrian statue of George III. The fate of a similar statue of George that was pulled down in New York in 1776 features in Chapter XI. This version dates from 1836 and is the work of Matthew Cotes Wyatt.

10. Walk down Cockspur Street then immediately turn into Warwick House Street. On the left is a small path that leads to a car park and behind that steps bringing you to Carlton House Terrace. Continue along the Terrace, looking out for number 15 and a statue of Queen Victoria, which dates from 1897.

11. Very soon you will see up ahead on the left the Duke of York Column, erected in 1833. The duke was the second son of George III, and commanded the British Army for many years.

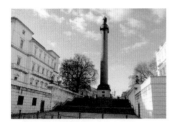

Duke of York Column

At one time, you could climb the internal stairs to the top of the column, but it became a suicide spot and was subsequently closed. The column was very unpopular amongst soldiers as each one had one day's pay docked to pay for it. The Duke of York was immortalised in the children's rhyme "The Grand Old Duke of York."

12. Just to the north and along Waterloo Place is yet another equestrian statue, this one showing Edward VII looking a little grander than when he cavorted with his many mistresses at The Cavendish Hotel around the corner.

13. Number 5 Carlton House Terrace is the Turf Club, founded in 1861, and one of the most exclusive establishments in London. The Daily Mail has described it as "the snooty Turf Club, the patrician haunt of aristocrats and plutocrats" and reported that Prince William and Prince Harry are amongst its members.

14. Carlton House was a large mansion that was located near

here, and was the London home of the Prince Regent, later George IV, in the late-18th century. Many of the works of art currently in the Royal Collection were acquired by the Prince Regent during this period, and adorned the walls of Carlton House. Several of the Prince's mistresses, including Mrs. Fitzherbert and Mary Robinson (both covered in this book), would have known the house very well. When George III died and the Prince Regent succeeded him as king in 1820, he decided Carlton House was not grand enough for him and he moved out. The house was demolished in 1826 and replaced with the present Carlton House Terrace.

Carlton House 1824

15. When you see the Charles de Gaulle statue (he was based in London during World War II) bear left into Carlton Gardens, and then walk down the steps on the south side to reach The Mall. By the steps are statues of George VI and his wife Queen Elizabeth, parents of the current monarch, Queen Elizabeth II.

16. If you continued up The Mall, you would reach Buckingham Palace. On this walk continue west, and then head north up Marlborough Road.

Marlborough House

17. On the right, visible over the brick wall, is the grand Marlborough House.
Today, it is home to the Commonwealth of Nations organisation. It was originally built for Sarah Churchill, Duchess of Marlborough, one of the most influential and wealthiest figures in England in the late-17th and early 18th centuries. Her grandchild Lady Diana Spencer was almost secretly married to the Prince of Wales. This Diana was also an ancestor of Lady Diana Spencer, who became the Princess of Wales after marrying the Prince of Wales in 1981. The first Lady Diana spent a great deal of time in Marlborough House with her grandmother Sarah.

18. The royal connection became more apparent when the royal family took over the house in 1817. Many members of the family lived here, including the Prince of Wales, later Edward VII. With his wife, Alexandra, this became the centre of the couple's extensive social life, attracting some of the most interesting people who lived in London during the second half of the 19th century. Edward's son George, later George V, was born here. Marlborough House was used by the royal family until the mid-1960s.

19. Continue along the road, looking out for a striking memorial to the aforementioned Queen Alexandra dating from 1932. It was unveiled by her son George V and was sculpted by Sir Alfred Gilbert. It shows three females—representing Faith, Hope and Love—holding a young girl. Alexandra was a very popular queen, remembered particularly for her charity work with children. She also had to put up a great deal with her husband's infidelity throughout their marriage. Gilbert was responsible also for the famous statue of Eros in Piccadilly Circus.

20. Near to the monument is The Queen's Chapel. It was designed by architect Inigo Jones (responsible for the Banqueting House in Whitehall) in the 1620s, and used by Catholic royals such as Charles I's wife, Henrietta Maria. The body of Queen Elizabeth, the Queen Mother, lay here after her death before being moved to Westminster Hall prior to her funeral in 2002. Members

The Queen's Chapel

of the public can attend services here on Sundays, usually at 8:30 am or 11:15 am. You can check at www.royal.uk.

21. On the left (west) side is the most prestigious royal palace in London—St. James's Palace. Henry VIII built the palace on the site of a leper hospital in the 1530s. Hans Holbein, as well as being the official court painter to Henry, also designed many other items for the royal family and painted some of the palace's ceilings at the time.

22. Many of the royals mentioned in the book lived here at some point in their lives, including Elizabeth I. The "forgotten" Prince Henry, son of James I, died here, as did Mary I. Charles I spent his last night at the palace before walking to his execution at Banqueting House in Whitehall.

23. Many royals were also born here, including Charles II, James II,

Queen Anne and Queen Mary. This explains why St. James's Palace became the most senior palace in the United Kingdom, something that remains to this day despite Buckingham Palace being Queen Elizabeth II's London residence. Ambassadors to the United Kingdom are still formally accredited to the Court of St. James's, reflecting the palace's senior status. Several royals still live here, and in recent years these have included Princess Anne, the Duke of York's daughter Princess Beatrice and Princess Alexandra. One wing is called York House, and this is where Princess Caroline lived before her disastrous marriage to the Prince of Wales (later George IV). Her story is told in Chapter XII. Prince Charles and his sons, William and Harry, lived in York House before Charles made nearby Clarence House his official residence.

24. At the top of Marlborough Road turn left onto Cleveland Row to see the Tudor frontage of St. James's Palace and continue along the Row.

St. James's Palace

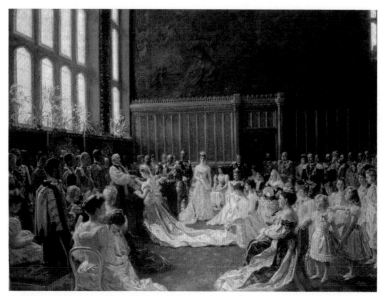

The Marriage of George, Duke of York, with Princess Mary of Teck in the Chapel Royal, St. James's Palace on 6 July 1893, 1894, Laurits Regner Tuxen (1853–1927), oil on canvas, 66.7 x 90.5 in (169.5 x 229.9 cm), Royal Collection

25. On the left you will see some high-level security. Behind here (on the south side) is Clarence House, which has been the official London residence of the Prince of Wales and the Duchess of Cornwall in recent years. Prince Charles' grandmother, Queen Elizabeth, lived here for half a century until her death in 2002. The young Princess Margaret also lived here for a while before moving to Kensington Palace. It is named

Clarence House

after the Duke of Clarence who became King William IV and lived here for many years.

26. From here continue down Cleveland Row and exit through a narrow path to reach Green Park—a nice place to stop for a picnic if the weather is good.

27. Walk up the pathway by the railings (north) to see the grand Spencer House facing the park. Built in the mid-18th century for John, 1st Earl Spencer, it is the best 18th-century town house of its kind in London. Queen Victoria attended a ball here in 1857. She arrived at 10:20 pm and the Morning Post reported, "The Queen was received in the

Spencer House

Entrance Hall by the Earl and Countess Spencer, whom Her Majesty graciously saluted." Lady Diana Spencer, who became Princess of Wales in 1981, was descended from this side of the aristocratic Spencer family. You can visit Spencer House on Sundays.

28. Continue along the park pathway and look out for a very narrow alley on the right (a hundred yards or so after Spencer House).

29. This leads you to St. James's Place and follow the map to St. James's Street. When the country celebrated Victory in Europe Day on May 8, 1945, Princess Elizabeth (later Elizabeth II) and her younger sister, Margaret, went out celebrating, doing the conga, hokey cokey and Lambeth Walk down St. James's Street and having the sort of fun sought by young people when they realise a war is over. The rare experience of the princesses being anonymous during this special celebration would inspire a feature film, *A Royal Night Out* (2015).

30. Before you continue left up St. James's Street, look over to the right side. This contains shops that have served the royal family, and some of the most famous figures in modern history, for centuries—including hatters Lock & Co., founded in 1676 and the oldest hat shop in the world. Others include John Lobb (shoes) and Berry Bros. & Rudd (wine merchants). As you walk up St. James's Street turn right on Jermyn Street on the right and continue up it a short way before stopping at Bury Street. On the north side is Wiltons (55 Jermyn Street) and just down Bury Street (number 16) is Quaglino's. Both were favourite restaurants of Princess Margaret when she was at her most social.

31. Retrace your steps and continue up St. James's Street. White's, arguably the single most exclusive club in the world, is just up on the right. It was founded in 1693, and generations of the British aristocracy, conservative politicians, bishops and members of the secret services have been members here. Current royal members are said to include the Prince of Wales and Prince William. Past members have included Sir Oswald Mosley, Evelyn Waugh, Edward VII and David Niven.

From here you continue north to Piccadilly, and then turn left to Green Park where the walk began. ✦

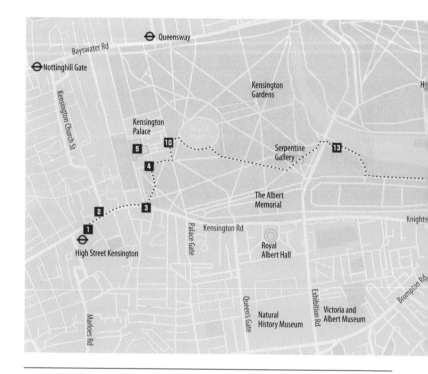

KENSINGTON PALACE TO BUCKINGHAM PALACE VIA HYDE PARK

This walk explores two of the royal family's London residences—Kensington Palace where Princess Diana once lived, and Buckingham Palace, official home of Queen Elizabeth II. Between these two palaces lies Hyde Park—one of the capital's great public spaces. This walk begins at High Street Kensington Underground station. (Note: It is possible to visit Kensington Palace and parts of Buckingham Palace at certain times. Check the websites below for information as you may wish to book tickets before setting out on the walk.)

1. Head east out of the Underground station, along Kensington High Street—one of the most upmarket thoroughfares in London.

2. At the corner with Kensington Church Street (on the left) is the Kensington War Memorial, unveiled in 1922 and originally commemorating the men of Kensington who died during World War I. It also refers to Princess Louise's Kensington Battalion, and the princess herself unveiled the memorial (it was designed not by her but by

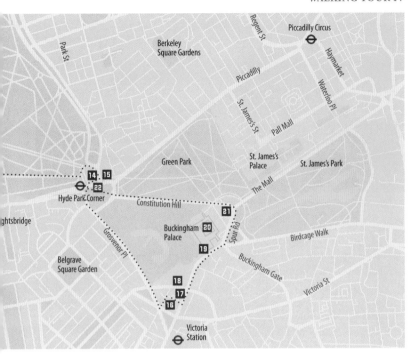

Hubert C. Corlette). Louise, the artist daughter of Queen Victoria, was a well-regarded sculptress and highly popular with the public (see Chapter XIII).

3. Continue on until you reach Kensington Gardens on the left. Head through the gate into the gardens (by a red telephone box), and follow a path on the left towards Kensington Palace up ahead.

4. Walk along the south side of the palace, getting a view through the perimeter gates. An equestrian statue of William III lies between the palace and the gate.

5. Kensington Palace is one of the best-known royal residences. Originally it was a country house in the village of Kensington. King William and Queen Mary, looking for a country residence not too far from London because William had asthma, bought the house in 1689—just a year before William defeated James II at the Battle of the Boyne (see Chapter IX).

Kensington Palace

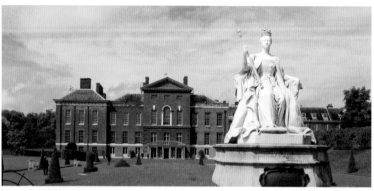

Kensington Palace

6. Sir Christopher Wren, architect of St. Paul's Cathedral, planned the design for an expanded house, which became the principal residence for the royal family for the next few decades (William died here). Another famous architect, Nicholas Hawksmoor, designed the Orangery for Queen Anne, and it was here that she had a furious argument with Sarah Churchill, the de facto power behind the throne up until that point. This dysfunctional relationship inspired the Oscar-winning film *The Favourite* (2018). Sarah Churchill was the grandmother of Lady Diana Spencer, an ancestor of the other Lady Diana Spencer who would become Princess of Wales in 1981.

7. Kensington Palace stopped being used by reigning British monarchs after George II died here in 1760. Now, more junior members of the royal family call it home.

8. The public can visit parts of the palace, and it is normally open daily 10 am-6 pm (until 4 pm November to February). Highlights include the palace gardens and the King's State Apartments. You can book tickets to visit the palace at www.hrp.org.uk/kensington-palace/visit.

9. Many of the royals mentioned in this book have lived at Kensington Palace. Queen Victoria was born here in 1819; on June 20, 1837, she was awoken in her bedroom to be told that her uncle, William IV, had died and that she was now queen of England. Her daughter, the "Bohemian Princess" Louise, also lived here for many years and had an art studio within the palace.

10. Continue along and turn up the Broad Walk (with the palace to your left). Shortly you will reach a statue of Queen Victoria that is the work of her daughter Princess Louise. It is said Louise had to have the windows of her apartment bricked up to stop her husband sneaking off into

the park at night to meet local soldiers.

11. Just past here (behind the palace gate) is the Princess Diana Memorial Garden. Diana originally lived here in Apartments 8 and 9 with the Prince of Wales after their marriage in 1981, and remained here for another fifteen years, long after their divorce. After Diana died tragically in 1997, the gates of the palace were covered in messages and flowers, and it became the focus of an outpouring of national grief; her funeral cortege left the palace on its way to Westminster Abbey. Princes William and Harry spent much of their childhood here, and it was fitting that Harry and Meghan Markle chose to formally announce their engagement in the Memorial Garden.

12. Other royals who have lived here include Princess Margaret (in 22-room Apartment 1A). In the 1960s, she entertained many famous people here including Peter Sellers and Dudley Moore. Prince Philip lived at the palace with his mother just before he married Elizabeth II. More recent residents include Prince Harry and Meghan Markle, who moved into Nottingham Cottage (nicknamed "Nott Cott") in the palace's grounds. Harry proposed there. William and Kate, the Duke and Duchess of Cambridge, have lived at the palace since 2013, originally

in Nottingham Cottage but more recently in Apartment 1A.

13. From Kensington Palace follow the map in a southeasterly direction passing to the right-hand side of the Round Pond, and following a major path. On the right you pass the Albert Memorial that remembers Prince Albert, Queen Victoria's husband, and after a few minutes you reach a road with the Serpentine Gallery on your left. Walk left up the road and then turn right to reach the rather underwhelming Princess Diana Memorial Fountain, which was opened by Queen Elizabeth II in 2004. From here head towards the southeast corner of Hyde Park, with The Serpentine lake on your left. Bear right to continue along Rotten Row, still used by horse riders, and where the royals once travelled along on their way to Kensington Palace.

14. You reach the edge of the park, going through a grand archway and turn left to reach Apsley House, which boasts the address "Number 1, London." This was the home of the Duke of Wellington, who later became prime minister after his famous victory over Napoleon at Waterloo in 1815. If you have time you may wish to visit as it has a superb collection of art, with works by Rubens, Canova, Thomas Lawrence, Titian, Velázquez and Goya.

The Waterloo Gallery at Apsley House

15. A mansion at 145 Piccadilly (the site of InterContinental London Park Lane now) stood to the east of Apsley House before it was destroyed by German bombs in World War II. This was the home between 1927 and 1936 of the Duke and Duchess of York and their children, Elizabeth and Margaret. The duke would become George VI upon the abdication of his elder brother, Edward VIII, and the family would move to Buckingham Palace (almost next door).

16. By Apsley House take the pedestrian tunnel to the centre of Hyde Park Corner, then bear right to take a second pedestrian tunnel to reach Grosvenor Place. Walk along here, with the tall wall on the left marking the exterior of Buckingham Palace Garden. After a few minutes follow the map to turn right into Beeston

Place. Just up on the right is The Goring Hotel. Queen Elizabeth II is not seen dining out very often in London, but The Goring is one establishment she likes. It became better known after Kate Middleton stayed here the night before her wedding to Prince William at Westminster Abbey in 2011. Prince Harry was reported to have stayed up late the night before the wedding, jumping off a balcony in the hotel at 3 am.

The Goring Hotel

17. Follow the map into Victoria Square (right beside the hotel). In the centre of the square is a modern statue of Queen Victoria, unusual as it shows her aged around 20. Nearly all the other statues of the monarch in London show Victoria as an aged, unhappy looking figure.

18. At the top of Victoria Square bear left, to walk up Buckingham Palace Road. After you cross Lower Grosvenor Pl, all the buildings on the left are part of Buckingham Palace, the official residence of the queen.

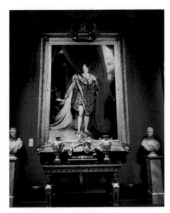

The Queen's Gallery

enough to be invited to the garden parties held in the summer. Each summer for 10 weeks you can visit the State Rooms within the palace (usually late July to end of September), when the queen is in residence in Scotland at Balmoral Castle. Highlights include the Picture Gallery, which contains many other examples of the queen's art collection (visit www. royalcollection.org.uk/visit/the-state-rooms-buckingham-palace for current opening times and to book tickets).

19. On the left, after a few minutes, is The Queen's Gallery, Buckingham Palace. It displays items from the vast Royal Collection; many of the works of art featured in this book are held within the collection. It is open most weeks of the year, from 10 am (9:30 am during the summer) to 5:30 pm (last admission at 4:15 pm). But it is always best to check on the website and book tickets ahead of your visit if possible (visit www. rct.uk/visit/the-queens-gallery-buckingham-palace).

20. Buckingham Palace was built for the Duke of Buckingham in 1703, and was later acquired by George III as a residence for his wife, Queen Charlotte. However, it only became the principal residence for the monarchy when Victoria became queen in 1837. It is not generally open to the public, although many are lucky

21. When finished, continue on to the front of Buckingham Palace and the large Victoria Memorial facing it outside the gates. The monument was unveiled in 1911 by George V.

22. From here you can walk down Constitution Hill to return to Hyde Park Corner, where there is an Underground station. If you have energy left to do the St. James's Walk in this book, you could also walk across Green Park to the Underground station of the same name, where that walk begins. ✦

Buckingham Palace

 INDEX

LOCATIONS OF THE PAINTINGS

Title	Page	Collection	Section/Place	City	Count
Mary Tudor/Catherine of Aragon (1485–1536)	49		Kunsthistorisches Museum	Vienna	Austria
Cromwell Lifting the Coffin-Lid and Looking at the Body of Charles I	98		Musée des Beaux-Arts de Nîmes	Nîmes	France
The Death of Mary Queen of Scots (1587)	65		Musée des Beaux-Arts de Valenciennes	Valenciennes	France
Portrait of Anne of Cleves	43		Musée du Louvre	Paris	France
Charles I at the Hunt,	101		Musée du Louvre	Paris	France
Anne Boleyn in the Tower of London	41		Musée Rolin	Autun	France
The Murder of the Sons of Edward IV	17		Museum Kunstpalast	Düsseldorf	Germa
Henry VIII (1491–1547)	39		Palazzo Barberini, Galleria Nazionale d'Arte Antica	Rome	Italy
Hans Holbein the Younger, self-portrait	47		Uffizi Gallery	Florence	Italy
Mary I of England (1516–58)	55		Museo del Prado	Madrid	Spain
The Trial of Catherine of Aragon (1485–1536)	48		Birmingham Museum and Art Gallery	Birmingham	UK
The Death of Frederick, 1st Duke of Schomberg, at the Battle of the Boyne	119		National Trust, Mount Stewart	County Down	UK
Henry VII, Elizabeth of York, Henry VIII and Jane Seymour	37	Royal Collection	Haunted Gallery, Hampton Court Palace	East Molesey	UK
Barbara Villiers, Duchess of Cleveland (c. 1641–1709)	105	Royal Collection	Hampton Court Palace	East Molesey	UK
Frances Stuart, Duchess of Richmond (1648–1702)	111	Royal Collection	Hampton Court Palace	East Molesey	UK
Charles II (1630–1685)	107	Royal Collection	Throne Room, Palace of Holyroodhouse	Edinburgh	UK
Catherine of Braganza (1638–1705)	109	Royal Collection	Throne Room, Palace of Holyroodhouse	Edinburgh	UK
James VII & II (1633–1701) when Duke of York	121	Royal Collection	Chamber, Palace of Holyroodhouse	Edinburgh	UK
The Battle of Culloden	135	Royal Collection	Lobby, Palace of Holyroodhouse	Edinburgh	UK
Prince Henry Benedict Clement Stuart (1725–1807)	141		Scottish National Gallery	Edinburgh	UK
Prince Charles Edward Stuart (1720–88)	133		Scottish National Portrait Gallery	Edinburgh	UK
The Princes Edward and Richard in the Tower (1483)	21		Royal Holloway, University of London	Egham	UK
Diana, Princess of Wales (1986)	215		Royal College of Physicians and Surgeons	Glasgow	UK

William III Landing at Brixham, Torbay, 5 November 1688	130		National Maritime Museum	Greenwich	UK
The Rainbow Portrait	63		Hatfield House	Hertfordshire	UK
Queen Victoria at Osborne	184	Royal Collection	Horn Room, Osborne House	Isle of Wight	UK
George II (1683–1760)	136	Royal Collection	Ambassadors' Entrance, Buckingham Palace	London	UK
George III (1738–1820)	150	Royal Collection	East Gallery, Buckingham Palace	London	UK
The Royal Family in 1846	175	Royal Collection	East Gallery, Buckingham Palace	London	UK
Whitehall from St. James's Park	224	Government Art Collection	Department of the Environment	London	UK
The Murder of Rizzio	72		Guildhall Art Gallery	London	UK
John Cabot and His Sons Receive the Charter from Henry VII, 1496	27	Parliamentary Art Collection	East Corridor, Houses of Parliament	London	UK
The Ambassadors	46		National Gallery	London	UK
The Execution of Lady Jane Grey	51		National Gallery	London	UK
King Richard III	22		National Portrait Gallery	London	UK
King Henry VII	31		National Portrait Gallery	London	UK
King Edward VI and the Pope	44		National Portrait Gallery	London	UK
Lady Jane Grey	56		National Portrait Gallery	London	UK
Queen Elizabeth I, William Cecil, 1st Baron Burghley, Sir Francis Walsingham	66		National Portrait Gallery	London	UK
Queen Elizabeth I	71		National Portrait Gallery	London	UK
King James I of England and VI of Scotland	80		National Portrait Gallery	London	UK
Barbara Villiers, Duchess of Cleveland with her son as the Virgin and Child	110		National Portrait Gallery	London	UK
Peter Lely (1618–80), self-portrait	115		National Portrait Gallery	London	UK
Allan Ramsay self-portrait	139		National Portrait Gallery	London	UK
Maria Anne Fitzherbert (née Smythe, 1756–1837)	160		National Portrait Gallery	London	UK
Wife & no wife - or - a trip to the Continent	162		National Portrait Gallery	London	UK
The Trial of Queen Caroline 1820	167		National Portrait Gallery	London	UK
Conversation Piece at the Royal Lodge, Windsor	197		National Portrait Gallery	London	UK
Anne Boleyn	230		National Portrait Gallery	London	UK

Victoria, Princess Royal, Princess Alice, Princess Helena, and Princess Louise	183	Royal Collection			UK
The Marriage of Nicholas II, Tsar of Russia, 26th November 1894	189	Royal Collection			UK
Queen Elizabeth II	207	Royal Collection			UK
The Marriage of George with Princess Mary of Teck in the Chapel Royal	244	Royal Collection			UK
American Commissioners of the Preliminary Peace Negotiations	154		Winterthur Museum, Garden and Library	Delaware	USA
Sir Thomas Lawrence (1769–1830), self-portrait	164		Denver Art Museum	Denver	USA
Pulling Down the Statue of King George III	147		New-York Historical Society	New York	USA
Henry Frederick with Sir John Harington in the Hunting Field	77		The Metropolitan Museum of Art	New York	USA
Henrietta Maria and the dwarf, Sir Jeffrey Hudson	94		National Gallery of Art	Washington D.C.	USA
Sir Thomas More with His Daughter After His Sentence of Death	40	private collection			
Self-portrait, Anthony Van Dyck	93	private collection			

Places are subject to change.

LOCATIONS AND THEIR HOMEPAGES

Country	Place	Home Page
Austria	Kunsthistorisches Museum	www.khm.at/en/
France	Musée des Beaux-Arts de Valenciennes	valenciennesmusee.valenciennes.fr/
France	Musée du Louvre	www.louvre.fr/en/homepage
Italy	Galleria Nazionale d'Arte Antica	www.barberinicorsini.org/en/
Italy	Uffizi Gallery	www.uffizi.it/en/the-uffizi
Spain	Museo del Prado	www.museodelprado.es/en
UK	Birmingham Museum and Art Gallery	www.birminghammuseums.org.uk/bmag
UK	National Trust, Mount Stewart	www.nationaltrust.org.uk/mount-stewart
UK	Hampton Court Palace	www.hrp.org.uk/hampton-court-palace/
UK	Palace of Holyroodhouse	www.rct.uk/visit/palace-of-holyroodhouse
UK	Scottish National Portrait Gallery	www.nationalgalleries.org/visit/scottish-national-portrait-gallery
UK	Royal Holloway, University of London	www.royalholloway.ac.uk/about-us/art-collections/visit-us/
UK	Royal College of Physicians and Surgeons	heritage.rcpsg.ac.uk/
UK	National Maritime Museum	www.rmg.co.uk/national-maritime-museum
UK	Hatfield House	www.hatfield-house.co.uk/
UK	Osborne House	www.rct.uk/collection/near-you/osborne-house#/
UK	Buckingham Palace	www.rct.uk/visit/the-state-rooms-buckingham-palace
UK	Department of the Environment	artcollection.culture.gov.uk/
UK	Guildhall Art Gallery	www.guildhall.cityoflondon.gov.uk/art-gallery
UK	Houses of Parliament	www.parliament.uk/about/art-in-parliament/
UK	National Gallery	www.nationalgallery.org.uk/
UK	National Portrait Gallery	www.npg.org.uk/
UK	Royal Academy of Arts	www.royalacademy.org.uk/
UK	The Weiss Gallery	www.weissgallery.com/
UK	Victoria and Albert Museum	www.vam.ac.uk/
UK	Wallace Collection	www.wallacecollection.org/
UK	Westminster Abbey	www.westminster-abbey.org

UK	Ashmolean Museum, University of Oxford	www.ashmolean.org/
UK	Windsor Castle	www.rct.uk/visit/windsor-castle
UK	Tate Collection	www.tate.org.uk/
UK	Royal Collection	www.rct.uk/
USA	National Gallery of Art	www.nga.gov
USA	New-York Historical Society	www.nyhistory.org/
USA	The Metropolitan Museum of Art	www.metmuseum.org/
USA	Denver Art Museum	denverartmuseum.org/
USA	Winterthur Museum, Garden and Library	www.winterthur.org/

CREDITS

ABOUT MUSEYON

Named after the Mouseion, the ancient library of Alexandria, Museyon is a New York City-based independent publisher that explores cultural obsessions such as art, history and travel. Expertly curated and carefully researched, Museyon books offer rich entertainment, with fascinating anecdotes, beautiful images and quality information.

Publisher: Akira Chiba
Editor: Francis Lewis
Proofing Editor: Janice Battiste
Cover Designer: CPI Inc.

ABOUT THE AUTHOR

Stephen Millar was born in Glasgow and later lived in London for 20 years before moving back to Edinburgh, Scotland. He is the author of the best-selling series *London's Hidden Walks* (volumes 1-3), *Edinburgh's Hidden Walks*, *London's City Churches* and *Tribes of Glasgow*. He is the main photographer for the book *London Architecture* and has written and provided photographs for a number of magazines and newspapers, including the UK publications The Sunday Herald, The Scotsman and iNews.